# Folk Art Ceramics

MILNER CRAFT SERIES

# Folk Art Ceramics

## JOYCE SPENCER

SALLY MILNER PUBLISHING

First published in 1994 by
Sally Milner Publishing Pty Ltd
558 Darling Street
Rozelle NSW 2039
Australia

© Joyce Spencer, 1994

Design by Photographix
Photography by Andrew Elton
Styling by Louise Owens
Typeset in Australia by Emsee Publishing Design
Colour Separation in Australia by Sphere Color Graphics
Printed in Australia by Impact Printing

National Library of Australia
Cataloguing-in-Publication data:

Spencer, Joyce
    Folk art ceramics

    ISBN 1 86351 152 0.

    1. Pottery craft. 2. Folk art. I. Title. (Series: Milner craft series)
738.15

# Photography Credits

*Plate 3*
Hat block from Victoria's Old Charm Antiques

*Plate 5*
Bucket from Victoria's Old Charm Antiques

*Plate 7*
Roll of ribbon from From Lois With Love

*Plate 8*
Basket from Tully's Northside Timber Stripping and Finishing

*Plate12*
Fishing baskets from Tully's Northside Timber Stripping and Finishing

*Stockists*
From Lois With Love
165 Middle Head Road,
Mosman, NSW 2088
Telephone: (02) 969 6847

Tully's Northside Timber Stripping and Finishing
Telephone: (018) 609 793

Victoria's Old Charm Antiques
82 Sydney Road,
Willoughby, NSW 2068

**By the Same Author**

*The Art of Teaching Craft* by Joyce Spencer and Deborah Kneen, Sally Milner Publishing, 1993.
*Folk Art Cards*, Sally Milner Publishing, 1993.

# Foreword

The acceptance of a person as an artist is based upon the quality of their finished work in a chosen field. An artist who can cross over to a different field and produce work of an equally high standard is indeed a very talented person. When that person is an accomplished teacher and author, it is well to take note and look forward to her next book with interest and enthusiasm.

Joyce Spencer is such a person. A long time, and dear, friend, she has used her fine talent to produce the first book to use folk art painting techniques on ceramics.

To date, ceramics, that is, slipcast ceramics, has been largely influenced by the American teaching methods used in seminar programs. The dominating role they have played has meant that American methods have to date been the source of all the designs and colours used in this craft.

A new and exciting approach is welcome.

Ceramics has so much to offer students. Painters of all levels are able to create pieces to suit their own home, both in style and colour. This book, produced by Joyce, gives the folk artist a new surface to paint on, and the ceramics student new ideas, designs and techniques to paint.

It is an exciting book that breaks new ground. The designs are a delight to the eye, and will also appeal to a large number of people wishing to take up a new craft. And the illustrations and methods outlined in the book are easy to understand.

Craft of all kinds is growing in popularity in Australia and is becoming an accepted way of life for all ages and both sexes. This growth has stimulated the development of a group of people who have extended themselves into the area of publishing their work, thus giving an underlying strength to the Australian craft industry.

I applaud Joyce for her efforts, and for *Folk Art Ceramics*.

Gary Alderson,
Managing Director,
Alderson's Crafts, Kogarah,
Aldax Industries, Revesby.

# Contents

# Contents

# Acknowledgements

My sincere thanks, once again, to my husband Geoff and to Sally Milner and her staff. To Gloria Circosta, Gary and Sandra Alderson and Deborah Kneen, all of whom are enthusiastic about my painting on ceramics.

I am very grateful to the ceramic studio owners who have shared with me their time, expertise and encouragement; they have made *Folk Art Ceramics* possible.

# Introduction

Folk painting on ceramics is not something new. Thousands of years ago, when the first clay pots were fired, clay was mixed with water and matter such as blood and fibre to make what is known as 'slip'. This slip was applied to the surface of the pot, with fingers or sticks, and a design or decoration that was inspired by the environment was produced.

Perhaps fired clay was discovered when food was cooked in packed earth in open fires. This hardened clay was found to be superior to the sun-dried primitive brick — and the campfire had become the kiln. Down through the ages and stages of ceramics, every country has made its own contribution to ceramics by way of refined clays, slips, decoration, glazes, moulds or kilns.

The first moulds were woven, coiled or twined baskets. Clay was pressed into this mould then removed from the basket and fired. Sometimes the clay was fired in the basket. The woven or twined fibre imprint created the decoration on the pot. Later in history glazes were used to give a decorative finish to the clay objects.

In hobby ceramics today the desire to paint and decorate clay objects is still very much alive, and there are hundreds of mould shapes from which to choose. The clay used in hobby ceramics still retains the name slip and is especially formulated from water, clay, colourants and other additives. The slip is poured into prepared casting plaster moulds, the water is absorbed from the slip into the plaster walls, and a cast shape is obtained when the excess slip is drained from the mould. A mould may consist of several pieces, which are held together with large rubber bands. When the mould pieces are gently removed, the cast greenware shape is ready for you to apply your creative painting skills using underglazes, one strokes (concentrated coloured slips) and glazes.

Ceramists do not need pottery wheels. The shapes used, such as bowls, cups, mugs, platters and plates, are made for us. Ceramic studios have all the equipment and expertise required to produce the greenware for us. Nor will we be applying transfers or decals; what we are going to do is paint our designs with coloured slips and glazes. Once the folk artist has learnt about ceramics, and the ceramist has learnt about folk art, some fabulous ceramic pieces, painted in the decorative or traditional style of folk art, will result. But first, it is advisable for the folk artist to attend

ceramic classes and for the ceramist to attend folk art classes, in order to obtain the basic skills required in these crafts.

Detailed instructions and designs are given in this book, though, and the easy-to-follow, step-by-step directions will make it possible for you to begin painting on ceramic products. While the ceramic shape can be bisque-fired and painted with acrylic paints or with stains and then varnished, it is not possible to cover this aspect in this book.

Once the pieces have been painted with slips and glazes and fired, they will last forever. Everlasting, functional, food-safe and waterproof, the final ceramic piece will become a family treasure, a new challenge, and a new surface on which to paint. There is tremendous satisfaction to be gained from *Folk Art Ceramics*.

# Some Basic Information

## What is Ceramic?

Ceramic, from a Greek word 'keramos', simply means potter's clay or pottery. The clay is a soft to hard substance which, with the removal of moisture upon firing, becomes harder and brittle. The clay will contain different matter and minerals and vary in colour according to the locality from which it is obtained. Special clay mixes are made and used for different purposes, and some are refined more than others. Some clays need to be fired at different temperatures than others. To gain an understanding of the differences between clays, it is useful to think about the texture of a bathroom tile compared to that of a house brick, or to consider the delicacy of a fine porcelain dish.

The clay we use is made into a liquid slip. Its whitish colour is derived from its talcum content. Additives such as a deflocculating agent aid the flowing powers of the slip without the need of adding more water. Stoneware slip can be tinted with concentrated colours such as one-stroke slips and fired at a higher temperature. Not every piece of ceramic needs a gloss glaze; matte and satin finishes will also enhance our ceramic pieces. And like the potters of the past, each of us hopes to produce unique and individual ceramic pieces that are limited only by our imagination.

## What is Hobby Ceramics?

The term 'hobby ceramics' originated in America, where, in a commercial situation, part-time students learnt to prepare, underglaze and glaze greenware for everyday use. Teaching standards were set for the studio owner and the student. All products, including kilns, moulds, slips and glazes, were sold under the canopy of a named product. People were also encouraged to operate their own businesses from home. New product information and releases were given out and seminars were conducted. Teachers were given accreditation, societies were formed and trade shows were held, all of which helped to raise the standard of ceramic ware and decoration.

A whole new world of craft and hobby ceramics has been introduced to Australia. Studios and wholesalers have followed the same pattern as that in America and have successfully operated hobby ceramics for a number of years. Ceramic studios are situated in most areas and will be listed in the telephone book. A list of the ceramic studios in my area is listed in this

of years. Ceramic studios are situated in most areas and will be listed in the telephone book. A list of the ceramic studios in my area is listed in this book because that is where the shapes for this book were obtained. The shapes chosen should be available in most studios.

## The Local Studio

The ceramic studio is split into several working areas, depending on the size of the shop or factory space. The entry usually contains the counter, stock shelving, colour charts, books, and schedules for classes and seminars. Displays of completed work and forthcoming seminar pieces are nearby. Shelving is everywhere. Student work is usually kept isolated. Not everyone wants his or her work on public show, particularly if the piece is for a competition or a special event. Pieces ready for firing are also kept isolated. The kilns can be installed in the shop or in another area, but are not accessible to students or customers. Ceramic ware which has been fired is placed on shelving, ready for further glazing or collection.

A large proportion of the shop and its shelving is devoted to the display of greenware. This is where one is able to look, but not touch. At first, you are likely to want to purchase and paint every piece — the choice is almost endless. One sees old-fashioned jugs and bowls like those grandmother used to have, figurines, dinnerware, Christmas plates and decorations, mugs, teapots, vases, teddy bear money boxes, pots, ornaments, and so on.

At the rear of the shop is the pouring area, with vats containing slip, tables, drainage tables, benches, and shelving full of the plaster moulds. This is the hub of the studio. Greenware is to be found drying on the table before being moved to the studio. It is common practice among ceramists to purchase greenware from another studio, then bring it to class with them. The reason for this acceptable practice is that no one studio could hope to have every mould shape. Some studios will specialise in particular moulds, such as pots, large animals, figurines, dinnerware or different slipware, like stoneware. It is very interesting to go on a greenware crawl, and most studio owners know where a certain shape can be found.

Classes are either held in separate classrooms or in a section of the

shop. The classroom area may have a large table with chairs all around, or narrow tables placed in a U-shape. Classes normally last for the day or for several hours in the evening. I have found the class charges, the cost for the use of studio slips and firing to be quite reasonable. The studios have maintained a relaxed atmosphere and the people have been most companionable.

In recommending that the student attend ceramic classes, I have several reasons for this advice. There is a set learning program for the beginner. Less greenware is broken because it is kept in the studio. All facilities such as cleaning, stock, firing, tuition, disposal of waste are at the studio.

### Ceramic Classes

When, as a folk painter, I decided I wanted to learn the ins and outs of hobby ceramics, I chose a studio close to home and attended evening classes. I learnt the basic skills and then progressed to more advanced techniques with air brushing and glazes, gaining a greater understanding about glazes, underglazes, firing, etc. I soon became addicted, and wanted to paint larger pieces.

I attended day classes locally at another studio and found that there were differences. Looking back I must have asked a lot of questions, but no one seemed to mind. At first I used the class slips, for which a small charge was made, and then gradually purchased my own colours, glaze and equipment. The costs were comparable to folk art needs.

Not every ceramic studio teaches folk art with an indepth study of the traditions and techniques. Some studios hold folk art lessons but paint with acrylics on wood. Very few studios teach folk art with slips and glazes. Usually it is the student herself who chooses to decorate her ceramic pieces in this way, inspired by the very colourful and decorative ceramic products seen in magazines and shops.

One of the most interesting studios I have been through is in Adelaide. It is owned by Denise Ferris, an enterprising and energetic lady, full of innovative ideas. Her shop is a joy to visit. It is filled with folk art, ceramics, greenware and books. One is immediately inspired to want to learn both hobbies.

## Learning Folk Art

For the ceramist, learning to folk paint then applying it to ceramics is very exciting and rewarding, as it is for the folk artist to paint on ceramics for the first time. Folk art is mostly taught at folk art studios and shops, at home, or at day or evening classes held in a school or church. A list of venues is often advertised in the local paper. Some videos and books are available, but to my knowledge, nothing is available on folk painting on ceramics. There is an abundance of folk art designs in books that would look wonderful painted and fired on ceramics. It is possible to paint with acrylic paints and stains on the fired greenware called bisque, but this is a book in itself. We are going to paint with coloured slips, underglazes and glazes, and produce the ceramic pieces presented in *Folk Art Ceramics*.

The approach of the ceramist learning folk art and applying these new-found techniques to her shapes will merge with the folk artist learning ceramic techniques and painting on new surfaces; this partnership will be an exciting one. Techniques such as sponging, spattering and crackling are familiar to both styles of painting.

# How to Use
## This Book

S tep-by-step guide is given, along with designs, detailed instructions and colours. An explanation of the products, cleaning, transporting, firing and helpful hints is also provided. All painting is done with water-based slips, ceramic products that are made specially for firing. The painting instructions and techniques such as stroke painting and sponging are described in detail, and with practice all of the projects are possible.

Some equipment you will already have around your home. The same brushes can be used for each type of painting. The folk artist, though, would need to purchase glaze brushes and cleaning tools. Please check the list of equipment.

My style of painting, which I call my 'light airy-fairy style' (LAFS), flows freely throughout the book. You are painting without tracing. Trace by all means, but with practice you will soon be creating your own designs and colour schemes. Please do choose your own colours. The colours I have used are purely a guideline; change them to suit the home surroundings. Feeling good around colours you like is important to your well being and personality. We all see colour differently. No product names are given for glazes and slips as every studio uses different products, so, for instance, the colour blue to be used will be described as either mid blue, pale blue or dark blue. Please check against the colour plates.

# List of Equipment

**General needs:** newspaper; apron; paper towel; tile or saucer for palette; old towel; pen, pencil; disposable gloves; mask; hand cream; sheet foam; notebook; glycerine; plastic lids; paper doiley

**Practice painting:** two tubes of acrylic paint, e.g. white and red; scrap paper

**Masking fluid**

**Cleaning greenware:** dusting brush; basin of water; round sponge; long handled sponge; seam cleaner; sponge sander; double-ended spiral; clean-up tool; cotton buds

**Tracing:** stylus; pencil carbon; graphite paper; fine-point black pen; greaseproof paper

**Carbon pencil:** for drawing

**Brushes (general):** — cheap Chinese (assorted sizes); glazing-fan brush

**Brushes (painting):** synthetic — Nos. 1, 3, 5 (round); Nos. 5, 8 (flat); No. 0 (script liner); ⅛" (3 mm), ¼" (6 mm) Cormack 2940 dagger; No. 6 Cormack 2930 wedge

**Underglaze colours:** mid blue; pink; dark green; black; yellow; yellow-orange

**One strokes:** white; black; orange; aqua; light, medium and dark of red, yellow, brown, green, blue, pink

**Glazes:** clear; food-safe; red-safe; pink-safe; terracotta

**Sandstar glazes:** cream; yellow; orange; medium green

# Moulds

**M**oulds have been used to replicate shapes for a long time. Clay moulds have been used for many hundreds of years. These were smeared with release agents to release the clay, porcelain and ceramic shapes from them. Iron shapes, for instance, were cast in sand moulds. Later plaster of Paris was utilised for clay moulding when it was found that it absorbed moisture from clay; gradually this plaster has been refined to a modern-day casting plaster which removes an even greater amount of moisture. This allows special slips to be manufactured which, even though they contain water too, can be poured into the moulds. Ceramic studios employ special pourers to do this work as it is quite heavy and skilled work.

It is important that the greenware shape is released from the mould at the right time, at which point handles, etc, can be applied. The shapes are then placed on wooden shelving to dry. One can tell a lot from looking at a piece without handling it. Reject anything that is not up to standard, or will make for very difficult cleaning, or is lopsided, or has an ill-fitting lid. Remember, handle greenware with two hands and use great care.

# Firing

A ll firing is done in a kiln, and is part of the studio and ceramic process. Kilns vary in size and can be run on gas or electricity. For proper results, the firing of our beautifully painted pieces needs to be done under close supervision.

At the studio, when greenware is purchased, the student keeps a note of its cost. A normal fee for firing greenware is half the cost of that piece. Later on, when the glaze is fired, another half cost fee is also charged, and so on if a third firing were needed for a gold application. In costing the piece for sale, therefore, firing is taken into account. Depending on how busy the studio is, firing is not usually done every day.

Glazes need a different firing temperature to that required for greenware and bisque. Black glaze, for instance, is often fired alone. Other underglazes, such as some darker pinks and red in particular, need the correct glaze on top. The kiln has to be loaded in a special way for best results, so the heat can be distributed evenly. It is best left to the experts.

When plain greenware is first fired it is called bisque, or biscuit. Some ceramic procedures require this firing first in order to apply special glazes such as bark. Please follow the firing instructions for your project.

Once again, if you are taking painted greenware to the studio for firing, carry it carefully. I am always most impatient for the results.

# Understanding Underglazes

## Underglazes

Underglazes simply go under the glaze. It is your painting medium and is made into a slip from clay, water and colourants. Underglazes can be opaque or transparent. Greenware which fires white does not necessarily have to be given an underglaze. The design can be applied with one strokes only, and given light washes of colour (see 'Small Jug and Basin', Colour Plate 3).

Underglazes come in many colours and most need three applications to provide a solid colour and coverage. When applying an underglaze, the greenware or bisque piece needs to be wiped first with a damp sponge.

METHOD
1.  Select colour, then read the label and shake well. The slip in the lid can also be used.
2.  In a small jar, mix the underglaze with water in a 50:50 ratio. Only mix as much as you will require for the piece. Apply one coat.
3.  When dry, apply two more coats of full strength underglaze. On a large piece work the paint in a different direction, using the glaze brush. On a small area use the Chinese brushes.

Should hairs from the glazing brush stay on the underglaze, do not worry as they will burn off during firing.

When applying underglaze, it is important to ensure that ridges do not form. The brush should be fully loaded and gently painted, not worked into the surface. The consistency should be nice and creamy and not dry, so mix thoroughly.

If you are looking for a particular colour or result, it is advisable to do a test piece first by painting on a broken greenware piece or a cheap shape. Some ceramists may be doing a dinner setting for a customer; a sample could also be painted in this instance, to show to the customer before-hand.

## One Strokes

One strokes are underglazes. The colours are transparent, but are very concentrated; they can be intermixed to make another colour or mixed with water. They can also be used for blending, shading, dry-brushing or

painted on top of underglazes, and two colours can be applied on the same brush. These strokes and other techniques are explained more fully in 'Stroke Work' (page 20). The one stroke type of slip usually can be identified by the smaller size of the bottle. The bottle has a pouring lid, because only a very small amount of slip is needed at one time on the brush. Painting can be done straight from the smaller pots. The colours of one strokes remind me of the old china pots that were used to grow a single, but majestic, chrysanthemum plant. On the small 'Dark Blue Vase' (Colour Plate 3), which is painted using a one-stroke slip, white is the only colour used for the design.

When painting in the light airy-fairy style, the design is painted using one strokes. Also, black one stroke, applied using a fine-script liner brush, is great for fine detailing (see 'LAFS Salad Bowl', Colour Plate 8, and 'Ashleigh's Tea Set', Colour Plates 10 and 11).

## Glazes

Glazing is the final touch to your piece once it has been underglazed, decorated and fired. It not only waterproofs but also gives a lovely protective gloss to your work and is a traditional part of the ceramic process. Glaze is basically glass which melts and flows during the firing process and then hardens. We do not, however, want the glaze to flow off the piece, so to prevent this, a flux of chemicals is added.

Formulae for glazes were often secret, and it is possible to find many recipes for specific glazes amongst potters. Once again, the history of glazing is fascinating. The first time that sand reacted on a piece of clay that was being fired, thus forming a glaze, is unknown. Some historians date this original form of glazing back to about 800–900 BC. Metallic glazing came much later.

Glazes of today have little or no lead content, but it is still wise to check first. Glazes can be opaque or clear. Special glazes are made for use on containers used for food or cooking. Matte and satin finishes are possible, too. Speciality glazes are available. These are fascinating and give a very realistic look, resembling wood or aged crackling. Some contain crystals that burst and change colour in the firing. Other glazes produce a finish such as the rough-textured one used on the 'Poppy Toilet-roll Holder' (Colour Plate 9).

Unfired glazes are not the same colour they will be once the ceramic piece has been fired. A clear waterproof glaze, for instance, will be pink, and will cover your painted design; this glaze will turn clear and transparent after firing, however, thus revealing your design once again.

The only coloured glaze used in this book is the terracotta, which is used on part of the 'Lemon and Orange Daisy Bowl' (Colour Plate 4).

Some colours such as pinks may fade under a glaze, and red may react differently under certain glazes. This is why one needs to read labels carefully and ask for the appropriate glaze. Most labels will state 'food-safe', but each company's product differs and the number of applications and coats of glaze may vary from product to product.

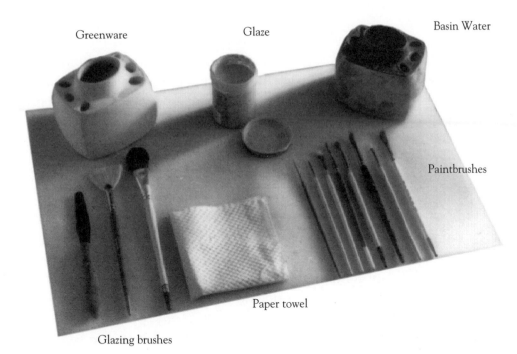

Greenware       Glaze       Basin Water

Paintbrushes

Paper towel

Glazing brushes

TO APPLY THE GLAZE

1. Read the label first. Wear gloves and observe the safety rules specified on the label.
2. Choose the correct glaze: for example, one that is food safe. Wipe your piece with a sponge.
3. Protect the work area with newspaper. If roll glazing the inside of a vase or cup, follow the instructions below for roll glazing.

4.   Using your glaze brush, either your fan or mop type, dip the brush into the glaze and generously flow the glaze on with your brush. Do not miss any spots and try not to work the glaze into the surface. Apply two coats, drying well between coats, and applying each coat in a different direction.

Your piece is now ready for another firing. Again, this is an exciting stage. With all your work hidden under the glaze, you will no doubt wonder how it will look. We have to paint a lot of repetitive pieces to be sure of an accurate result.

*Roll Glazing*

Roll glazing is an easy method of coating the inside of pieces such as bowls, cups, vases and teapots with spouts. The glaze is diluted with water to a creamy consistency which will pour and run slowly. I usually keep this glaze separate in a wide-mouthed jar and pour the excess glaze for the inside of the piece back into the jar.

TO ROLL GLAZE

1.   Protect the working surface with newspaper.
2.   Clean the piece with a damp sponge.
3.   Prepare the glaze and pour it into the piece. Gently roll the glaze around, covering the entire area. Check for complete coverage in such areas as the inside of spouts. Any excess glaze can be run back into the glaze container.
4.   Allow to drain and dry upside down on newspaper. When dry, turn upright and use a damp sponge to wipe off any spillage on the piece.

Roll glazing requires a little practice at first. Missed spots can be touched up with a fan brush. One coat of glaze is sufficient coverage here.

At first, when I started painting on greenware and bisque, I tended to buy small functional pieces, which meant that my decoration area was restricted. Later, as my confidence increased, I moved on to larger pieces. The more you paint on ceramic, the more accurate are the results.

The beauty of making these one-off pieces, like the 'Courting Couple', (Colour Plate 12), is that they are unique. There is no other goose quite

like yours — or mine. Certainly choose the colours you like, and make any alterations to the designs. We all view things differently. Use your creative ideas and talents. *Folk Art Ceramics* will get you started, fire your imagination, and help you to paint bigger and better ceramics.

## Metallic Gold

The use of gold on ceramics is really the extra final touch; gold is actually an overglaze. Gold especially has been used to decorate ceramic pieces for centuries; it is a sign of wealth. I have not used a lot of gold because it is very expensive to buy, but it certainly does look terrific on a special piece such as the 'Christmas Plate' (Colour Plate 7), in which the gold outlines all the shapes and the border. Very fine wisps of gold are painted on the 'Sponged and Spattered Plate' (Colour Plate 1) to resemble marble; and scrolls are outlined with gold on the 'Brown Dinner Plate' (Colour Plate 2).

The gold, which is suspended in a solution that paints red, comes in a very small bottle. When fired the red turns to gold. A white gold can also be obtained, as can silver and bronze.

I keep my gold in a lid that is taped safely in place with sticky tape. One can't afford to lose a drop of the precious liquid metal.

The piece to be painted should be clean and wiped over with rubbing alcohol, and a special essence used for cleaning the brush.

METHOD
1. Store safely. Read instructions. Clean the piece.
2. Using a very fine liner 00 or 0 brush, outline or make fine strokes with the brush (see 'Stroke Work', page 20) to give your piece those extra little touches. Clean your brush with methylated spirits.
3. Fire the piece.

As the application of gold requires another firing, making three firings in all, it is wise to take this extra cost into account. Metallics and gold can only be applied to fired glaze.

**Cleaning Greenware**

There is no need to be nervous when cleaning greenware. It is better to be cautious and observe the rules that follow; then breakages will be minimal.

I found that as a folk artist painting on tin and wood, I must have been very rough, compared to the light handling needed for greenware.

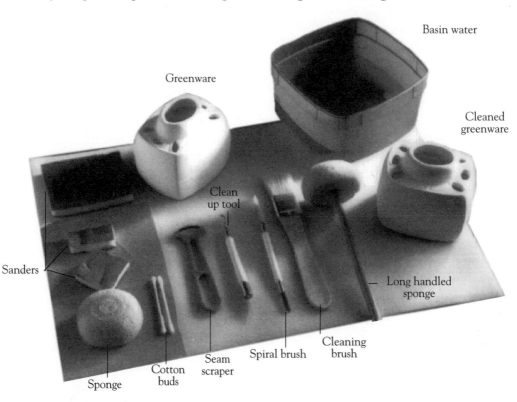

METHOD

1. Handle every piece with two hands.
2. When selecting greenware, the shop proprietor will take it off the shelf for you. If you break it, you have to pay for it. That is the rule.
3. Do not pick up greenware by the handles.
4. Use clean hands. Grease affects the surface.
5. Prepare the work space. Cradle the piece with foam sheet, or use old towels. Newspaper is good, too. Finally, place paper towel under the piece to collect the fine powder. This can be shaken into a bin from time to time.

6.  The greenware should be dry. Select carefully. Avoid detailed moulds at first and pieces with flaws.

7.  Do not put pressure on the greenware.

8.  Most moulds have seam lines, the result of the mould pieces joining. With the arrowhead of the metal cleaning tool, scrape diagonally across the seam lines, using gentle strokes. Check the base too, the lids, the inside, for lumps and bumps.

9.  With the sponge-sander, and rubbing in a circular motion, smooth the seam lines, other edges and imperfections.

10. Stubborn pin holes may need to be filled by mixing some powder and water and filling the holes. Sand when dry.

11. Save some powder in a small lidded container. Should a small crack or breakage occur, it is often possible to repair the damage with this powder. A product is also available for patching up breaks. Follow the instructions on the bottle.

12. When you are satisfied with your nice clean, smooth piece of greenware, check the inside again and clean with the long-handled sponge. Use your dusting brush, and do not blow clean. Spouts need special attention and should be cleaned with the spiral brush or damp cotton buds.

13. Wring out a small round sponge in water and wipe it gently over the piece. Do not rub, as any shine affects the porous surface, which may reject the ceramic finish.

14. Finally, check your piece to see if it is level. If not, place a piece of coarse sandpaper on newspaper and turn your piece around and around until level. Sand and clean.

Now that you have cleaned your article, you are ready to choose the design, decoration and techniques to be used in the next step. Place your piece carefully to one side and clean up any mess.

Select the underglazes, one strokes and your brushes, and you are ready to start 'folk art on ceramics'.

### Choosing a Project to Decorate

Start with a small project such as the 'Toothbrush Holder' (page 36), 'Blue Vase' (page 40) or 'Slap-Slip Vase' (page 37), until you feel comfortable handling ceramic and painting with a new medium.

Perhaps your first piece is to be a gift for a family member or friend (your hand-painted ceramic pieces will be sought after). Until the ceramist feels more practised with her folk art, and the folk artist starts painting on ceramics, simple items such as those mentioned can look beautiful.

Painting on ceramics is such an interesting hobby; there is so much to learn. Walking into a ceramic studio for the first time is quite over-whelming; there is so much one could decorate. I practised on some of the broken pieces of greenware with ceramic slip to get the feel of the new 'paint'. If you are not working in the studio, but taking your work home, you will need to transport it very carefully, preferably in a box, and resting on shredded paper. I know one lady who puts her piece into a well-padded box, puts the box on the back seat of her car, and puts the seat belt around the box. It's good to get our priorities right.

All the product colours for the various types of slips, underglazes and glazes are displayed on small ceramic tiles that are glued onto boards, making for easy selection.

# Basic Painting Techniques & Procedures

## Painting with Slips

The round and flat brushes listed for slip painting are made from synthetic fibre and are used only for base coating, liner work and stroke work, being specifically designed for these techniques. They have lots more bristles compared to the cheaper Chinese brushes made from pig bristles, which are used for underglazing, glazing and dry-brush work. This is what folk and stroke painting is all about: the correct brush, the correct amount of slip on the brush and the right amount of pressure on the brush. Folk artists already know how to do this and need little instruction in order to paint with slip. They may find slip drags a little, but adding water helps.

A habit I keep from folk painting is to put my slips onto a saucer. When finished for the day, I cover them with plastic to prevent drying out. The slips can be revitalised with water and mixed into a creamy consistency again. One cannot do this with paint. For the ceramist, all the strokes as well as the history of folk art painting are explained at length in my book *Folk Art Cards*. Many of the designs featured in this book could also be used on ceramics.

Folk painting is really 'people painting', the traditional Bavarian Bauernmalerei style of painting translating as 'farmer painting'. Folk artists draw on many styles of painting — traditional, decorative and naïve — from many countries. All have their place in folk art. Most techniques, strokes and styles are brilliantly devised, and make sense to the new painter. It is possible to paint whole flowers like tulips, leaves and borders with strokes. The ceramist will be overjoyed at the books, videos, patterns, styles, colours that can be used. It is like opening Pandora's box.

## Setting Up

I like to paint on the kitchen counter. The height and light provided are right for me — and I am close to the sink and the telephone. I have a jar with water and some paper towels and I work on an old towel. My brushes stand upright in a jar.

To practise strokes, I suggest you purchase a tube of coloured acrylic paint and scrap paper, or practise with one-stroke slip on a tile or black cardboard.

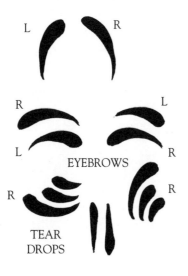

No pressure

Pressure

MAKING A STROKE

COMMA STROKES –
PAINT IN ALL DIRECTIONS

L          R

R          L

L          R

EYEBROWS

R          R

TEAR
DROPS

## Stroke Work

*Round Brush*

1.  Using a palette knife, loosely mix some paint and water together to a creamy consistency.
2.  Take up some paint into the brush; this is called loading the brush.
3.  Hold the brush like a pencil, place the tip of the brush lightly down on the paper. It should be a fine point. Apply pressure to the brush. Notice the hairs splay out and the stroke is quite wide. It is this combination of pressure or no pressure that makes strokes.

Comma strokes are gently turned to the left or to the right, up or down strokes are called tear drops, horizontal strokes are eyebrows. Comma strokes, therefore, start with pressure and end with no pressure. The brush is not just loaded and flicked across the practice paper, hoping for a stroke. You have to be in control of the brush; mutter away to yourself that you are going to paint a comma stroke or an 'S' stroke. It is going to the right or to the left, just where you want it, pulling the pressure or releasing the pressure on the brush. Do not lift your hand from the paper until you have completed the stroke.

It is not easy at first, but after practising and practising, it comes to you. Practise with all of the brushes. You will soon paint with confidence. I love this old Chinese proverb; 'With time and patience, the mulberry leaf becomes a silk gown.'

## S' Stroke

This stroke is made by commencing with no pressure, then applying pressure, and again ending with no pressure. We paint the straight line through the 'S'. It is a very useful stroke for bows and ribbons, petals and decoration and for making leaves appear to turn back. Both the flat and round brushes are used for this stroke.

## Fine Detailing

The script liner brush is ideal for detailing and small strokes. The hairs are longer than normal and can flow around and around when the paint is mixed with a little more water. Try writing your name and practise little squiggles and bows.

## Flat Brush

The flat brush makes strokes like the 'S'. By turning the brush on the flat edge, we get a wide line. Turning the brush on the side, or chisel edge, gives us a fine line. With practice one can paint bows strokes, ribbons, half circles, buds and roses. Blending and shading can be done with this brush (see 'Flat-brush Blending', page 27).

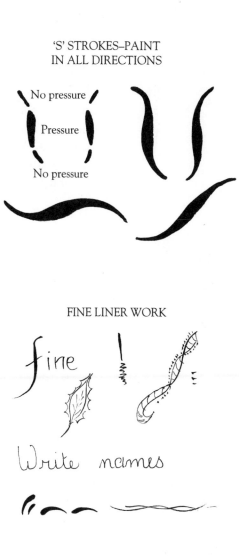

'S' STROKES–PAINT IN ALL DIRECTIONS

No pressure

Pressure

No pressure

FINE LINER WORK

fine

Write names

### Double-loading

The round brush can be loaded with one colour, then tipped into another colour such as white. This gives a striped stroke that has the bulk of the paint at the tip of the stroke. It is not advisable to have too much slip on the brush, because too thick a slip may crack under the glaze and cause bumps.

All brushes are suitable for this technique.

### Brush Sizes

When deciding which brush to use, the size of the flower or shape to be painted dictates which brush to use. Please look at the design. If, for instance, a daisy is small, then choose a small brush; if the daisy is large, then use a larger brush. Fine detailing needs a fine liner brush and can be used on all sized shapes. More pressure on the brush will give a thicker line.

We all have our favourite brushes. I am quite sure I paint better strokes with some brushes than others.

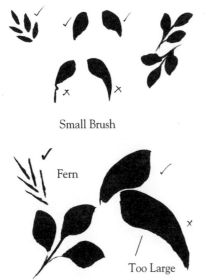

Small Brush

Fern

Too Large

Large Brush

### Dagger Brushes

Dagger brushes are among my favourites. I use them for my light airy-fairy style. Because the hairs are cut at an acute angle, the slip gets right down into the metal ferrule of the brush, so I really look after these brushes. Clean them frequently.

To paint with this brush, which makes lovely leaves, pick up some slip in your brush and lightly touch down on the paper. The result: a narrow leaf. Now lift the brush, reload, and pull the stroke over to

the left and stop. Pick up more slip and pull the stroke over to the right. Do not pull down tails; the stems are painted later with a liner brush.

Use brushes of both sizes to paint clumps of leaves with a thin mix of slip. It is again pressure on the brush which makes these leaves. Place several colours close together, and then make a thin wash. The results are most interesting as the colours intermix (see 'LAFS', Colour Plate 5).

*Wedge Brush*

I keep all brushes when they are worn. I have found that I can make an interesting pattern with the hairs of this wedge brush, due to the nature of the brush, which is normally used for ribbons and bows. I mixed some thin slip and wiped off the excess on a paper towel first and applied the brush all over the 'Courting Couple' (Colour Plate 12) to give a feathery look. I also used the small wedge and green slip on the 'Green Breakfast Set' (Colour Plate 6).

Other old brushes can be used to sponge small areas, make background flowers and sprays like lilac. It is these little inventive touches that soften our painting and tie it all together.

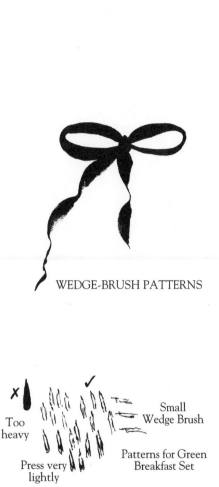

WEDGE-BRUSH PATTERNS

Too heavy

Press very lightly

Small Wedge Brush

Patterns for Green Breakfast Set

Large Wedge Brush

Too heavy

Pattern to look like feathers on geese

## Light and Airy-Fairy Style of Painting

Throughout this book I refer to my style of painting as light and airy-fairy style (LAFS). It is a style of painting I devised for students so that they could learn to paint freely without tracing. It has many possibilities for the innovative painter and hopefully will enable you to apply it to your favourite flowers and techniques (see 'LAFS', Colour Plate 5).

METHOD

1. Using a fine liner brush and three shades of green, paint stems and trails of the different greens, over and under each other, and vice versa, to resemble intertwining vines and climbers.

2. Using a dagger brush, paint groups of three leaves and single leaves, using different colour greens or a mixture. Place three greens close together, pick up a little of each and blend lightly. We want streaks of different colours. Paint the stems with a liner brush.

3. Using a liner brush, tip into another colour and lightly paint some ribbons and loops if you wish. Paint veins and stems.

4. Paint on some flowers such as roses or daisies in a cluster near the loops and throughout the trails.

5.   Paint in some filler flowers such as push forget-me-nots or dots and complement with tick leaves, described following and shown in Colour Plate 3.

6.   Add some squiggles, fine leaves or tendrils and you have a quick and easy style of painting.

*Dots:* These are made by picking up slip on a pin head, a nail, the end of the paint brushor a stylus. They can be graduated or made into flowers.

*Filler Flowers:* These are made with a small round brush loaded with one or more colours. Push the tip of the brush down lightly, make five quick strokes in a circle, put a dot in the centre and you have little forget-me-nots or filler flowers to take up any little gaps in your design. Push some little green leaves around the flowers as well.

*Tick Leaves and Grasses:* These are made by loading a small brush with slip and simply ticking around the flower with a light flick of the brush.

There are other variations of the LAFS in this book, such as that used on the 'LAFS Salad Bowl', the 'Pink Planter' and others. I am sure you will recognise them.

## Blending

When working with slips, we often blend one or more colours together to give light and shade to areas such as leaves, petals and shapes. Blending can be done in three ways. The method of double-loading with a round brush has already been referred to under 'Stroke Work' (page 22). The second method is round-brush blending, used to apply slip to give light and shade to shapes. The third method uses the flat brush, where the colours are blended into the brush, then applied onto the shape, such as roses, rosebuds, leaves, etc.

### Round-brush Blending
*(see leaves on 'Blue Lemon Bowl', Colour Plate 4)*

This technique was used on the leaves of the 'Blue Lemon Bowl'. The leaves were given two coats of green underglaze, and when dry, were blended.

METHOD

1. Put out three shades of dark, medium and light green, and yellow or white. White or yellow can be used for the highlight.

2. On the left side of the leaf, apply light green. On the right side of the leaf, apply dark green. Do not apply the underglaze thickly; just gently wipe the colours on.

3. Blend with the medium green, working quickly from left to right. Try to avoid creating a demarcation line down the middle of the leaf. You may need a little water on the brush if the slip dries quickly.

4. To highlight with white or yellow, use a clean dry brush, pick up a little slip, wipe off excess on a paper towel and brush gently on the left side of the leaf, in the area where the light would shine.

Another way to highlight a leaf, so that the tip of the leaf appears to curl, is to paint an 'S' stroke on one side in white yellow or pale green (see 'Blue Lemon Bowl').

*Flat-brush Blending*

METHOD

1.  On a palette, place two contrasting colours of one strokes, such as pink and white. (The blending can be done on a tile or foil, and the practice painting can be done on black cardboard.)
2.  Pick up some pink paint on one corner of the flat brush, then pick up some white paint on the other corner of the brush. Move the brush backwards and forwards on the tile, blending and mixing the two colours, but keeping white on one side and pink on the other. When you come to paint the little roses and buds, the white remains on top of the stroke to suggest light, and the pink remains on the bottom to give the colour (see 'LAFS', Colour Plate 5, and 'Pink Planter', Colour Plate 3).

## Dry-brush Work

Dry-brush work is a similar technique to that used in folk art. In folk art, we use the dry brush mainly for highlighting and only one or two colours are used. In ceramic painting many colours are used. They are lightly applied one on top of the other to let the values and different colours show through. This technique can be used very creatively on borders, the centres of flowers and the tips of leaves and petals. It has been used on the layers of tail feathers on the 'Courting Couple', Colour Plate 12), and is great for animal fur. Dry-brushing is very effective on detailed pieces. When a final highlight, such as white, is applied, the piece seems to glow.

*Dry-brushing with Slips*

The cheaper Chinese brushes made from pig bristles are ideal for this technique. When working on a large area, use a large brush, and on a small piece, use a small brush. I often cut the bristles down a little when a lot of dry-brushing is required because the bristles become stiffer and more rigid closer to the metal ferrule of the brush, and this gives more

control to obtain a hairlike finish with many colour changes. Work on an old towel with some paper towels. Cradle the greenware with towels or foam.

METHOD

1. Put out the one-stroke slips you require on a palette. Work from dark to light colours.
2. Use water to dilute the slips, and mix with a palette knife or another brush. The working brush must be dry. When making a colour change, there is no need to wash the brush; just wipe it on the paper towel.
3. Dip the brush into the slip, and wipe off any excess on the paper towel. There should be very little slip on the brush. Apply very lightly at first with the darkest colour; this will most likely be the shadow. Work the brush back and forth or in one direction. Pick up some more slip from the paper towel or palette, removing excess. Check the brush frequently. It should always be dry and not wet with slip. We need a streaky, wispy look, not a painted look. A base coat colour can be applied first, then the dry-brushing done on top, working from dark to light.
4. Change to a lighter colour, working in one direction only.
5. Change again to a lighter colour and, working in one direction, move down the area until the required effect is achieved, applying the highlight last.

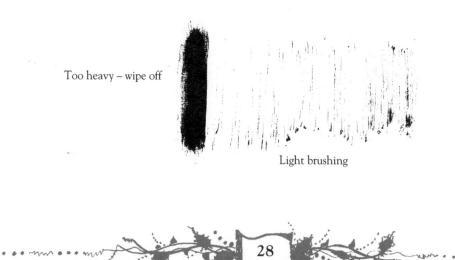

Too heavy – wipe off

Light brushing

'Ashleigh's Tea Set' (Colour Plates 10 and 11) was done in this manner; it was all dry-brushed, which required a lot of work, but produced very effective results. I painted some leaves, flowers and bugs on top of this dry-brushing, as it makes an interesting basecoat of underglazes.

## Sponging

Sponging on greenware is different to sponging on wood or tin. On wood, for instance, the paint sits on top of sealer, and there is a longer drying time. On greenware, one has to move quite quickly as the surface is very absorbent and the colours more concentrated, so it is better to do a little at a time and use very little pressure on the sponge. Again, use some broken greenware to practise on.

Glycerine, obtained from the chemist, is a very useful aid to sponging. It should be mixed 50:50 with water.

Sponges vary in texture, size and shape — for example, sea, household and the type used to wash the car — and therefore leave behind different markings. When little pressure and only a small amount of slip is applied the markings are distinct. If greater pressure and more slip than required is applied the end result will look more like that of painting or basecoating.

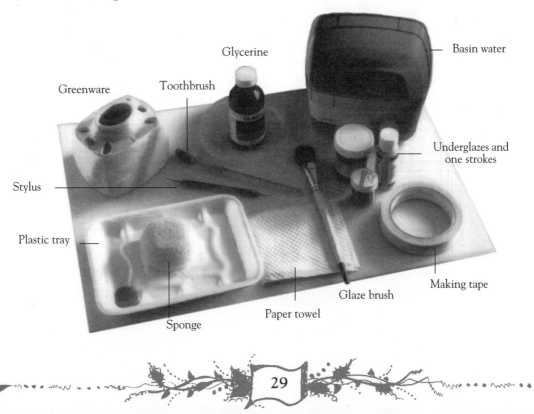

Glycerine

Basin water

Toothbrush

Greenware

Underglazes and one strokes

Stylus

Plastic tray

Making tape

Glaze brush

Sponge

Paper towel

METHOD

1. In one plastic lid or saucer, put out three colours of your choice, either underglazes or one-stroke slips. In another lid, put out some glycerine mix.
2. Wring out two sponges tightly in water. Dampen the greenware with glycerine with one sponge and pick up slip with the other.
3. Dab off the excess on paper towels.
4. Cradle the greenware with towels or foam. Handle carefully.
5. Mask off the area to be sponged. Refer to 'Masking' (page 32).
6. Quickly pick up some more glycerine in the sponge and some colours in the other. You need to work very quickly, dabbing lightly in a drift, or here and there. If drying out too quickly, apply some more glycerine mix. When changing to another colour slip, turn sponge and pick up another colour, keeping the colours close so that different values are obtained. Work a small area until you are pleased with the results. Change colours if necessary. A light application gives the pattern, a heavy application gives blobs of colour. These blobs can be hard to remove, so work quickly with the damp sponge.

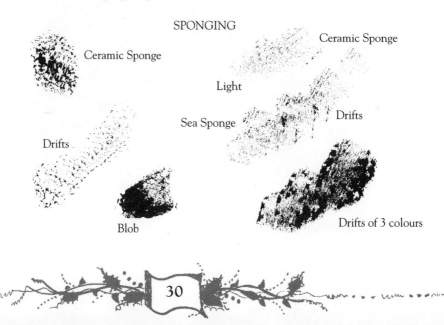

SPONGING

Ceramic Sponge

Ceramic Sponge

Light

Drifts

Sea Sponge

Drifts

Blob

Drifts of 3 colours

When you feel comfortable with sponging, experiment with different textured sponges, or rough material. Try more than three colours. A feather dipped in one stroke and then gently stroked over the sponging here and there is most effective.

Have fun.

## Slap-Slip

This technique works well for me on bowls, vases, jugs — in fact anywhere I need an interesting or varied background. The outside of the 'LAFS Salad Bowl' (Colour Plate 8) is done in this manner. I spilt some slip one day, and rather than waste it, decided to do something with it. I mixed some glycerine and water, put out some other greens and used the yellows left from sponging the inside of the bowl.

With my large Chinese brush, I really slapped the slip on in a crisscross stroke, picking up different colours with the glycerine mix and going all over the bowl. The result was quite subtle, but more dramatic colours can also be used effectively. It is a technique we use in folk art to paint clouds, to give a patchwork look and to represent grass.

If you wanted every finish to look the same, because, for instance, you were painting a dinner service, I would paint and fire a sample first, to be sure of the result. Try and avoid ridges when changing colours while slap-slipping.

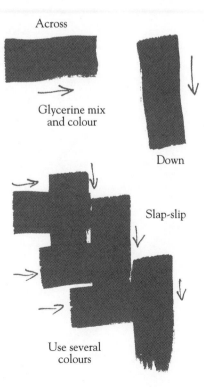

Across

Glycerine mix
and colour

Down

Slap-slip

Use several
colours

As I cannot always rely on my memory, I write down the colours used, particularly as there are so many different names to one colour; every brand calls the same colour something different.

### Spattering

Spattering resembles fly specks. It ages the work. Dried out underglazes can be reconstituted with a little water and used for spattering, otherwise diluted slips are used.

Take up some of the watery mix onto a toothbrush, tap off any excess and flick gently where you want it to go. Mask off any areas in which you do not want the spattering to go. The result is a fine speckled mist which softens the designs. Complete shapes can be underglazed, then spattered with different colours. The result resembles stone.

For larger blobs, take the slip up into a larger brush, and tap with another brush, at the position where you need the blobs to go. A mixture of both fine spatter and larger blobs is an interesting one (see 'Sponged and Spattered Plate', Colour Plate 1).

Light spatter

Blobs

Blobs and spatter

### Masking

Sometimes it can be hard to keep straight lines or to paint within a certain shape. To make this easier, we can use masking tape placed onto the greenware (see 'Olde Fashioned Iron', page 48).

For different sized stripes, two pieces of tape can be placed parallel to each other, and the width in the

middle painted into a band. The small 'Jewellery Box' (page 41) had the centre circle sponged: a circle is cut from a piece of paper, and the piece from which the circle has been cut is then positioned on the lid and the centre sponged; it is important to hold the edges firmly so the slip doesn't run underneath. For the sponged area in the 'LAFS Salad Bowl' (page 61), the tape was positioned in a wavy line. Interesting shapes can be made, as can accurate lines, by using this simple method.

## Masking Fluid

This is a rubbery solution that is painted onto an area we want to protect from other slips, underglazes or glazes. It comes off in the firing process or it can be removed before firing. When painting the 'Blue Lemon Bowl' (page 50), for instance, blue underglaze was applied and fired. When the lemons were painted with a special sand glaze, I wanted to protect them from the clear glaze, which should not be applied over the top of this special glaze. I applied a masking fluid to the lemons, then painted the clear glaze on the rest of the bowl. The masking fluid was burnt off in the firing, and no glaze went onto the lemons, which retained the rough sandy texture that I wanted.

Wax is another material which can be used as a masking medium.

## Tracing

In folk art and ceramics it is acceptable to trace and transfer a design we wish to paint onto our work. Not everyone can draw and design. When the outline is traced, it is recorded in our memory. You may even find that you surprise yourself and are able to draw the design freehand. Do try; a circle drawn with a carbon pencil is all that is necessary to indicate a flower, and a stroke can be a leaf. Most fine lines are painted freehand. My LAFS type of painting has no tracing — you are painting freely.

Before tracing and copying any design, please read any copyright information. In some books, the authors are quite happy for you to copy a design for your own use, or to teach that design, but not to mass produce the design, or a mould for that matter. Some people believe that if they alter a design slightly and change the colours, that this is acceptable. This, however, is not true. It is still an infringement of

copyright to do this, because a substantial part of the original design is still being used. It is always wise to check first or obtain the permission of the designer, publisher or author.

METHOD

To trace and transfer a design, use the following steps:

1.  Using a fine-point black pen, trace the design with greaseproof paper or a sheet of tracing paper.
2.  Position the design on the greenware.
3.  Slide a sheet of pencil carbon under the design. Hold firmly. With the end of the stylus or a toothpick, draw the outline of the design. It is not necessary to put veins in leaves, or stamens in flower centres, or outline comma strokes because we paint over the top of them with the underglazes and one strokes. The pencil carbon is burnt off in the firing. Remember not to lean on the piece of greenware and do not press too hard. Check from time to time that the tracing has come through. When painting, refer to your tracing, on which you have traced all the details.

    The tracings can be used over and over again.

Wrong          Right

# Safety Precautions

Some craft items such as paints, glues, varnishes and glazes may contain toxins. The teacher and student are strongly advised to read all labels carefully. If you are in doubt about a product, particularly if the piece is to be used for food and cooking, ask the studio teacher.

* Disposable gloves and masks are cheap. Wearing them may prevent skin and chest problems. The dust from greenware may be a problem for someone with a chest complaint.

* Not all of today's glazes contain lead, and while those that do have lead only contain a very small amount per jar, please follow the directions on the label.

* Once again, read labels carefully, and do not hesitate to ask questions.

* Avoid spraying in confined areas, either from spray cans or compressors.

* All products, both at home and in the studio, should be kept out of the reach of children.

* Hand and barrier creams are great for the hands, although any excess should be wiped off. Any grease that gets onto the surface of the greenware may cause damage to the finish of your ceramic piece.

* Food, too, should not be eaten around ceramics.

Following these few simple precautions will make you aware of safe working practices and good housekeeping for the hobby ceramist and the studio.

# Projects

## Sponged Toothbrush Holder (Colour Plate 1)

CLEANING TIPS

Use a spiral brush to clean the holes, and clean the inside thoroughly with a long-handled sponge.

TECHNIQUES

Sponging. Dots.

FIRINGS

Two.

Decorate with dots

GLAZING

Roll glaze inside. Check that the glaze is pink-safe; darker pinks may fade under certain glazes.

COLOURS

One strokes: Rose pink. Pale pink. Pale blue. White.

METHOD

1.  Dampen the holder with glycerine mix. Sponge around the sides and base with pinks and pale blue, sponging in drifts of colour (see 'Decorative Backgrounds', Colour Plate 1).
2.  Paint two coats of rose pink around the holes and the top of the holder.
3.  Using the stylus, dip into white and make small five-dot flowers with a blue dot for the centres. Put a row of white dots around the rim and holes.
4.  Fire the piece.
5.  Wipe clean. Roll glaze the inside with water and glaze mix. Masking tape could be applied over the holes to prevent spillage.
6.  Using the fan brush, apply two coats of glaze to the outside.
7.  Fire.

If you are pleased with the result, you could create a matching tooth-paste holder and soap dish, and also match all the other various shapes made for the bathroom.

## Blue Slap-Slip Vase (Colour Plate 1)

CLEANING TIPS
Use a long-handled sponge to clean inside.

TECHNIQUES
Slap-slip with one strokes.

FIRINGS
Two.

GLAZING
Roll glaze inside.

COLOURS
One strokes: Blue. Pale blue. Yellow. White. Aqua.

METHOD
1.   Wipe the vase clean. Put the glycerine mix in one plastic lid and the one strokes in another. Using a large brush, pick up the mix and then the colours and slap-slip in a crisscross motion over the piece. Only work a small area at a time. The cover can be solid to softly transparent, but the basketweave effect, with the different colours, should be apparent (see 'Brown Dinner Plate', Colour Plate 2).
2.   Fire the piece.
3.   Wipe clean. Roll glaze the inside, and when dry, apply two coats of glaze to the outside. The vase will be waterproofed when it is fired again.
4.   Fire.

This is a very imaginative and easy finish, it is just that little bit different from a plain underglaze, making it more interesting.

Most studios check the bottom of the vase for you. When the piece is placed in the kiln, it has to be placed on special supports, so that the heat can move around. These stilts often leave a tiny raised bump. These can be filed off with a special stone.

So slap-slip as you go!

## Sponged and Spattered Plate (Colour Plate 1)

CLEANING TIPS
Level the base.

TECHNIQUES
Underglaze. Spattering. Sponging. Gold liner work.

FIRINGS
Three.

GLAZING
Food-safe.

FINISH
This a faux finish which should resemble stone.

COLOURS
Gold. Underglaze: Black. One strokes: Dark and light blue. Medium and light green. Aqua. Yellow.

METHOD
1. Mix a little black with dark blue and, using an underglaze brush, apply two coats of this to the underside of the plate. Apply one coat to the inside of the plate.
2. Using some glycerine mix, lightly sponge dark blue in drifts over the plate. Turn the sponge and repeat with another colour such as aqua. Pick up more glycerine mix and blue.
3. Repeat the process with light green, then dark green, then yellow. By now it should be looking good, with the colours beginning to take on different values, and the drifts of colour apparent.

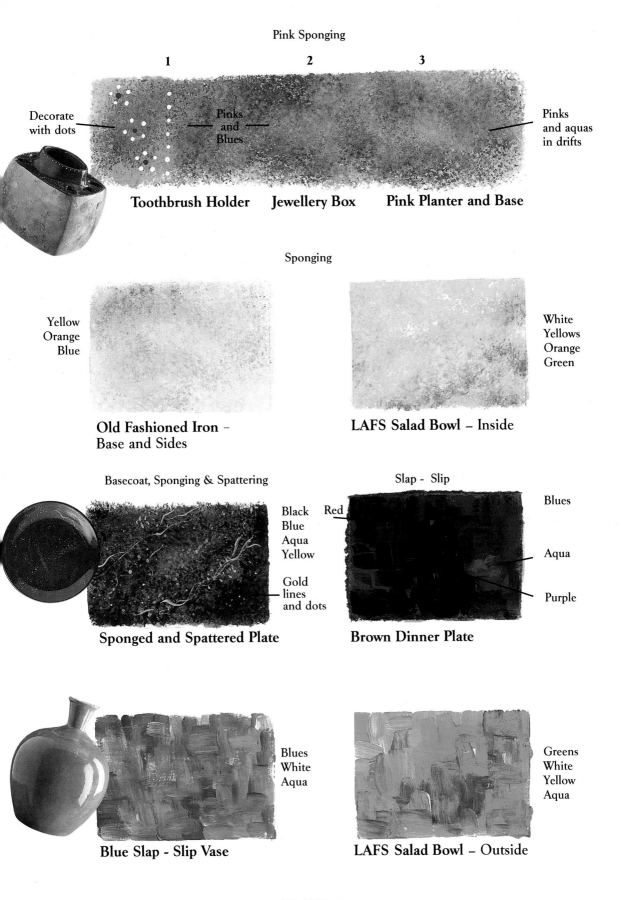

Pink Sponging

1      2      3

Decorate with dots

Pinks and Blues

Pinks and aquas in drifts

**Toothbrush Holder**    **Jewellery Box**    **Pink Planter and Base**

Sponging

Yellow
Orange
Blue

White
Yellows
Orange
Green

**Old Fashioned Iron –
Base and Sides**

**LAFS Salad Bowl – Inside**

Basecoat, Sponging & Spattering

Slap - Slip

Red   Black
Blue
Aqua
Yellow

Gold
lines
and dots

Blues

Aqua

Purple

**Sponged and Spattered Plate**

**Brown Dinner Plate**

Blues
White
Aqua

Greens
White
Yellow
Aqua

**Blue Slap - Slip Vase**

**LAFS Salad Bowl – Outside**

PLATE 1
Decorative Backgrounds

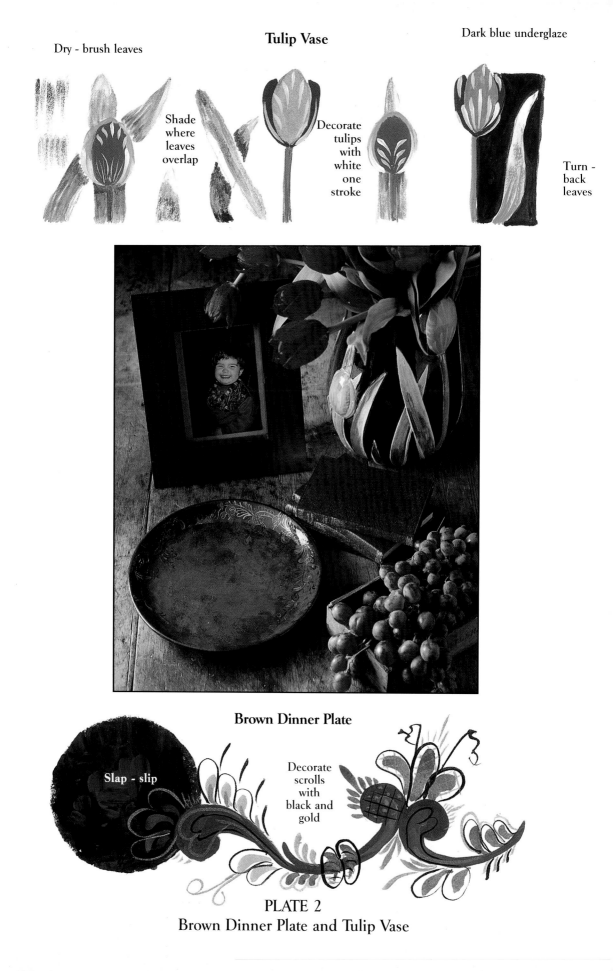

Dry - brush leaves

**Tulip Vase**

Dark blue underglaze

Shade where leaves overlap

Decorate tulips with white one stroke

Turn - back leaves

**Brown Dinner Plate**

Slap - slip

Decorate scrolls with black and gold

PLATE 2
Brown Dinner Plate and Tulip Vase

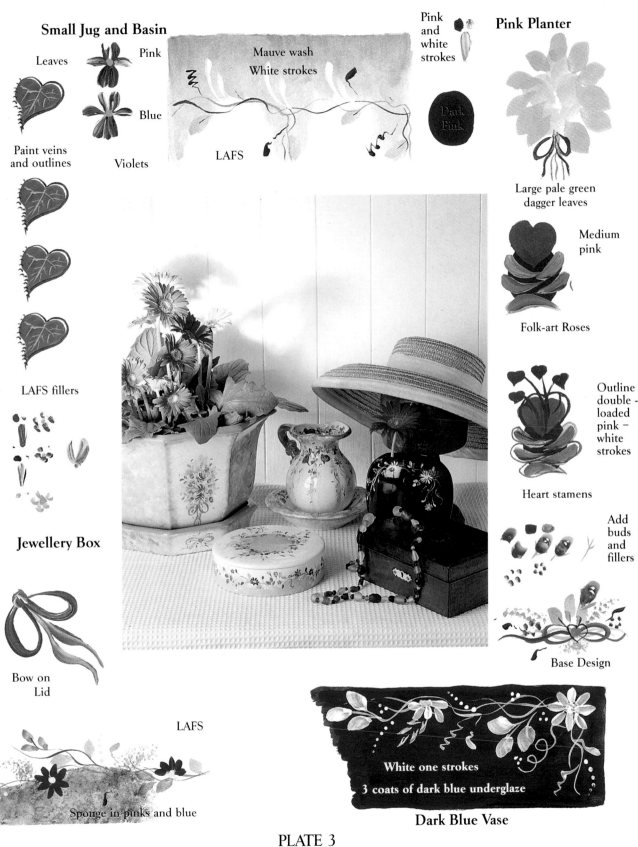

## Small Jug and Basin

Leaves

Pink

Mauve wash
White strokes

Pink and white strokes

## Pink Planter

Blue

Violets

Paint veins and outlines

LAFS

Dark Pink

Large pale green dagger leaves

Medium pink

Folk-art Roses

LAFS fillers

Outline double - loaded pink – white strokes

Heart stamens

## Jewellery Box

Add buds and fillers

Base Design

Bow on Lid

## LAFS

White one strokes
3 coats of dark blue underglaze

Sponge in pinks and blue

**Dark Blue Vase**

PLATE 3
Pink Planter and Base, Small Jug and Basin,
Jewellery Box and Dark Blue Vase

## Lemon and Orange Daisy Bowl

Paint daisies with underglaze gold

2 coats of terracotta glaze

Dots in centres

Decorate leaves and buds

Black liner work

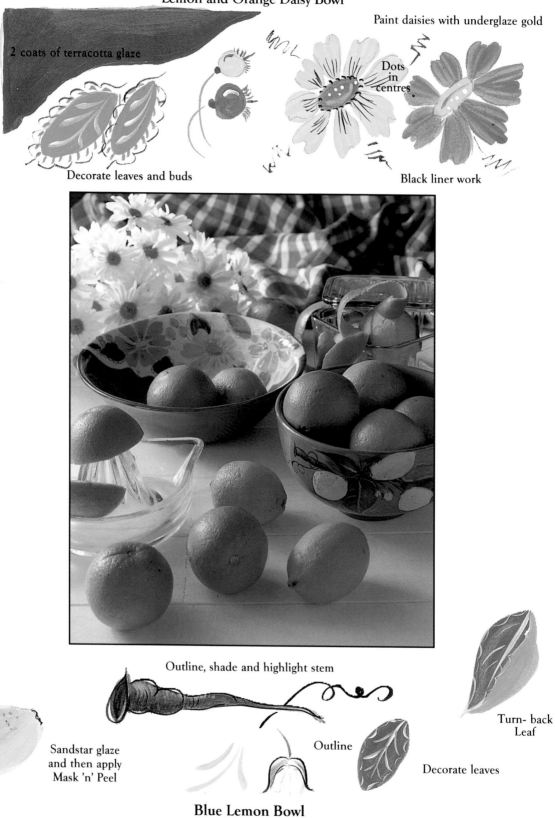

Shade

Outline, shade and highlight stem

Turn-back Leaf

Sandstar glaze and then apply Mask 'n' Peel

Outline

Decorate leaves

**Blue Lemon Bowl**

PLATE 4
Lemon and Orange Daisy Bowl and Blue Lemon Bowl

4. If there are any blank spots, a very light sponge of black can tie the colours together.

5. When you are pleased with the result, lightly sponge some drifts of yellow here and there. This is where the fine gold vein lines will go.

6. You are now ready to spatter. In plastic lids, mix slip and water together with an old toothbrush. Tap off the excess and spray where you want the spatters to go. If you don't want the colour to go in a certain spot, just hold a piece of paper up to stop the spray. Change colour and spray again. Try some blobs. The spatter will also fill up any gaps.

7. Fire the plate.

8. Wipe the plate clean and apply the food-safe glaze.

9. Fire.

10. Wipe the plate with alcohol.

11. Using a very fine liner brush and your precious gold, paint some very fine lines to resemble veins in a rock. Place some fine dots in clusters close to the yellow.

12. Fire.

Spattering is great fun.

Basecoated then sponged
Yellow is sponged in drifts

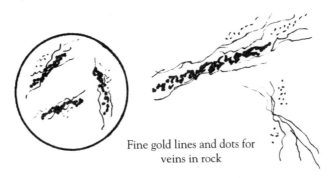

Fine gold lines and dots for
veins in rock

## Dark Blue Vase (Colour Plate 3)

CLEANING TIPS

Level the base. Check the inside of the piece.

TECHNIQUES

Underglaze. LAFS. Dots.

FIRINGS

Two.

GLAZING

Clear glaze. Roll glaze inside.

COLOURS

Underglaze: Dark blue. One stroke: White.

METHOD

1.  Wipe the piece with a damp sponge and apply three coats of dark blue underglaze. Work in a different direction for each coat; apply thickly because of the dark colour.
2.  Dry well.
3.  Paint white one strokes in LAFS using a liner brush and a dagger. Paint daisies with a No. 1 brush.
4.  Fire the vase.
5.  Roll glaze the inside. Apply two coats of clear glaze to the outside.
6.  Fire.

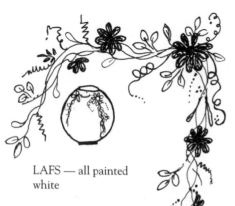

LAFS — all painted white

The design was painted with one coat of one strokes only, so it is amazing how transparent yet strong these one slips are on a dark background.

If dark blue is not your colour, then choose another colour. A dark

green underglaze and peach design could look lovely. The colour combinations possible are endless.

## Jewellery Box (Colour Plate 3)

CLEANING TIPS

A nice easy piece to clean.

TECHNIQUES

Masking. Sponging. Underglaze. LAFS.

FIRINGS

Two.

GLAZING

Roll glaze inside the bowl and the lid.

COLOURS

One strokes: Light blue. Dark blue. Purple. Yellows. White. Light green. Dark green. Light, medium and dark pink.

METHOD

1.  Cut a small circle from a piece of paper. Tape or hold it on the lid.
2.  Set out pinks and blue and glycerine mix for sponging. Sponge lightly in the central hole, pressing the paper down firmly to prevent slip from bleeding underneath. The base is sponged into a scalloped edge with the same colours. Apply little light drifts of pink colour above this edge here and there to give a background like blossom. (See Decorative Backgrounds', Colour Plate 1.)
3.  Set out colours on your palette and paint LAFS on the lid base.

Cut a template

Sponge in the hole

Sponge border. Drift pink colour lightly here and there

By now our colour range of slips has increased and we can add more colour interest to this style of painting.

4. Fire the pieces.
5. Wipe the pieces clean. Roll glaze the inside of the bowl and lid. Apply two coats of glaze to the outside.
6. Fire.

These are pretty little designs which make lovely gifts — all your own handpainted work!

Congratulations.

Paint LAFS

Push flowers

Violets

Double-loaded buds

## Lemon and Orange Daisy Bowl
## — Bisque Fired (Colour Plate 4)

Unlike the other pieces in this book, which are painted in the greenware state and then receive their first firing, this bowl is first fired after cleaning and before any painting is done.

CLEANING TIPS

Level the base. Fine sand bisque. Wipe the piece clean with a damp cloth.

TECHNIQUES

Tracing. Underglazing on bisque. Masking.

FOR FULL SIZE
ENLARGE TO
140%

FIRINGS

Two. (Please note that the piece was cleaned and fired once before painting the design.)

GLAZING

Clear food-safe. Terracotta food-safe.

COLOURS

Underglazes: Yellow. Orange. Midgreen. One strokes: Black. White.

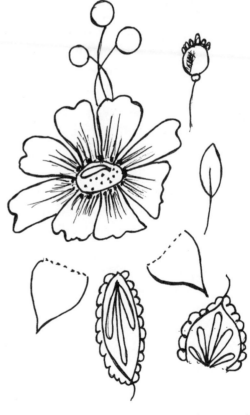

FOR FULL SIZE ENLARGE TO 120%

Inside of bowl has three daisies

Outside of bowl has one daisy

Trace a design made up of 3 or more daisies, berries and leaves depending on your own ideas and the size of bowl.

METHOD

1. Trace the design or freehand daisies and leaves on the inside and outside of the cleaned bisque bowl.
2. Apply three coats of underglaze to the daisy petals. Stroke from the top of the petal to the centre. Apply three coats of underglaze to the berries. Blend a little stroke of the contrasting colour onto the side of each berry. Paint the stem green. Apply dots to the berries.
3. Apply two coats of green to the leaves. When dry, paint some decorative comma strokes with white slip.
   Painting on bisque is similar to greenware. If the slip drags a little, add a small amount of water.
4. Apply three coats of the contrasting colour underglaze to the centres of the daisies. When dry, apply some tiny white dots with the liner brush and paint in a comma stroke of the contrasting colour.
5. Make a fairly thin mix of the black one stroke. Using a fine liner brush, decorate and outline leaves, centres and petals. Paint fine black squiggles in any gaps.
6. When completely dry, apply two coats of clear food-safe glaze over the painted design, making an irregular line, on both sides of the bowl. Normally, the inside of the bowl would be roll glazed, but because there is going to be another type of glaze applied as well, the glaze is painted on.
7. Dry thoroughly. When applying the glazes, masking tape can be applied to outline the area if you feel that your hand is not too steady. However, I am sure that by now you are becoming an expert.
8. Apply two coats of terracotta food-safe glaze to the remainder of the bowl, painting a neat edge on the rim where the edges of the different glazes meet.
   Most coloured glazes need three coats of the glaze. I felt that the colour was too strong and a more transparent finish was better, so applied two coats rather than three.
9. Fire the bowl.

Other coloured glazes, such as blue, green or black, would look lovely, too.

Painting on bisque is good when you live far from the studio. Most studios will gladly clean and bisque-fire for a small cost, which makes a bisque-finished piece a great product for mail order, as bisque is easier to pack and transport once fired, and the breakage rate is less. Greenware, on the other hand, needs to be thoroughly and expertly cleaned before firing, as any imperfections such as seam lines will show.

## Brown Dinner Plate (Colour Plate 2)

CLEANING TIPS

Level the base.

TECHNIQUES

Slap-slip. Underglazes. One strokes. Tracing. Rosemaling scrolls (rosemaling is a style of folk painting from Norway). Gold liner work.

FIRINGS

Three.

Trace or freehand

GLAZING

Clear food-safe.

FOR FULL SIZE ENLARGE TO 160%

COLOURS

Gold. Underglaze: Black. One strokes: Mid-blue. Light and medium red. Aqua. Purple.

METHOD

1.  Apply two coats of black to the underside of the plate. Apply one coat of black to the front. The colour does not need to be solid on the front. The slap-slip colours make a brown; this can also be painted on the back later.

2.  Put out all colours, except black, on a lid. Using a large brush and some glycerine mix, slap-slip colours over the plate. Concentrate some areas of

colour such as the aqua or red here and there. (See Decorative Backgrounds', Colour Plate 1.) A light sponge of a particular colour can look good here, too.

3. Allow the plate to dry. Hold the results of your efforts up to the light and choose where you want to decorate. If you have produced a lovely effect in an area, then you don't want to paint over it, so find another spot for your decorative scrolls.

Decorate

FOR FULL SIZE ENLARGE TO 160%

4. The scrolls can be drawn with the carbothello pencil or traced (see the detailed drawings and the colour plate). Apply two coats of a mid-red colour to the scrolls.

5. Decorate the scrolls with strokes of different-coloured one-stroke slips, then outline with black.

6. Fire the plate.

7. Wipe the plate clean and apply two coats of clear food-safe glaze.

8. Fire.

9. Wipe the plate with alcohol. Apply fine detailing with gold. The gold work should remain around the rim of the plate. (Over time on dinnerware, if gold is painted in areas where food is cut, the knives scratch the gold, so please be aware of this.)

10. Fire.

Embellish with gold

The fine liner brush decoration and the stroke work, and then the final touch of gold really make this plate something to be treasured, especially if it is placed on a plate stand for everyone to admire. If you intend making a number of dinner plates, you could make each one different by changing the colours of the scrolls.

FOR FULL SIZE ENLARGE TO 160%

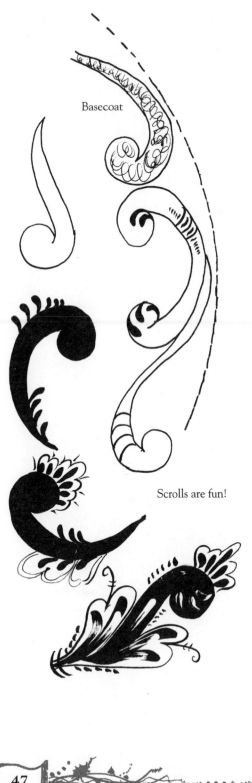

Basecoat

Scrolls are fun!

## Olde Fashioned Iron (Colour Plate 5)

CLEANING TIPS
Do not hold by the handle when cleaning the piece.

TECHNIQUES
Folk art strokes. Double-loading. Liner work. Sponging. Masking. LAFS.

FIRINGS
Two.

GLAZING
Clear glaze.

COLOURS
Underglaze: Blue. Yellow-orange. One strokes: Dark and medium blue. White. Pink. Yellow. Orange. Medium green.

Cut a template or mask

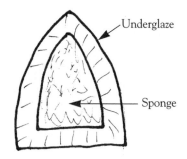

METHOD

1.  Set out sponge colours and glycerine mix. Yellow, orange and pale blue were used. Cut out base shape in paper or use masking tape to mask around the edge of the iron. Sponge lightly to obtain a pretty effect. (See 'Decorative Backgrounds', Colour Plate 1.)

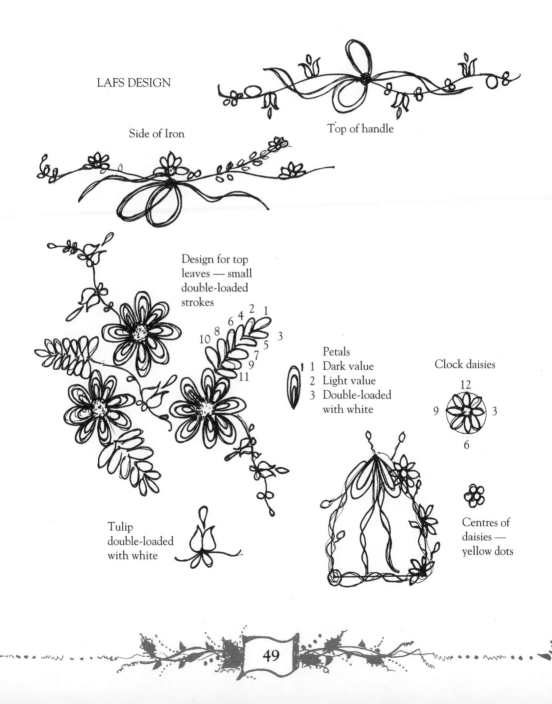

LAFS DESIGN

Side of Iron

Top of handle

Design for top leaves — small double-loaded strokes

4 2 1
6
8
10
5
7
9
11 3

Petals
1 Dark value
2 Light value
3 Double-loaded with white

Clock daisies

12
9     3
6

Centres of daisies — yellow dots

Tulip double-loaded with white

2. When dry, apply three coats of blue underglaze to the top of iron and around the sponging on the base. Apply three coats of yellow-orange underglaze to the handle and side rim of iron. When dry, mask off two rows with tape, leaving a narrow line in the middle. Paint three coats of blue underglaze here, which will give you an even, fine line. Alternatively, paint the line freehand with the liner brush. You can do it; just go slowly and carefully.

3. Refer to the illustrations and the colour plate as a decorating guide. The top has three daisies painted in the clock method and the strokes are double-loaded. Little stems and bows are painted on the handle and side. The base has some LAFS stems and leaves. The daisy petals are double-loaded strokes. The centres are yellow dots. The bow is made with the large round brush and a fairly loose mix of blue slips and water. When painting the loops, I like to work away from me, applying pressure as I take the loop down and no pressure as I turn the brush and come up. The tails are made with pressure on the brush initially, then no pressure, just wisping away at the ends. Two small strokes complete the tie of the bow.

4. Fire the iron.

5. Wipe the iron clean. Apply two coats of clear glaze.

6. Fire.

Many other kitchen pieces such as platters, mugs and bowls would look lovely painted in this manner.

## Blue Lemon Bowl (Colour Plate 4)

CLEANING TIPS
Level the base.

TECHNIQUES
Liquid masking. Underglazing. Round-brush blending. Liner work. Tracing.

FIRINGS
Two.

GLAZING

Clear food-safe (this glaze does not go over the lemons). Read the labels. Roll glaze inside the bowl.

COLOURS

Underglaze: Medium blue. Sandstar glaze: Yellow and orange. One strokes: Dark, medium and light green. Brown. White. Black. Yellow.

METHOD

1. Apply three even coats of medium blue underglaze.
2. Fire the bowl.
3. Trace the design onto the bowl. Paint the stems brown. Paint the leaves medium green. Round-brush blend the leaves and stem. Paint a turn-back leaf with an 'S' stroke of white. The veins and outlines are also white.
4. The buds are double-loaded yellow and white strokes. Paint small green—white leaves for the buds. Paint fine black tendrils and outline the buds and stem. Paint some groups of yellow comma strokes here and there.
5. The lemons are given three coats of the special sandstar yellow glaze. When dry, blend a little orange then white onto one side of the lemons to give them a little lift.
6. When completely dry, cover the lemons only with the liquid masking fluid. The masking fluid will prevent the clear food-safe glaze from going onto the rough textured lemons.

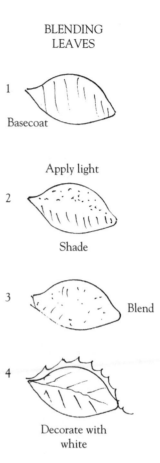

BLENDING LEAVES

1 Basecoat

2 Apply light / Shade

3 Blend

4 Decorate with white

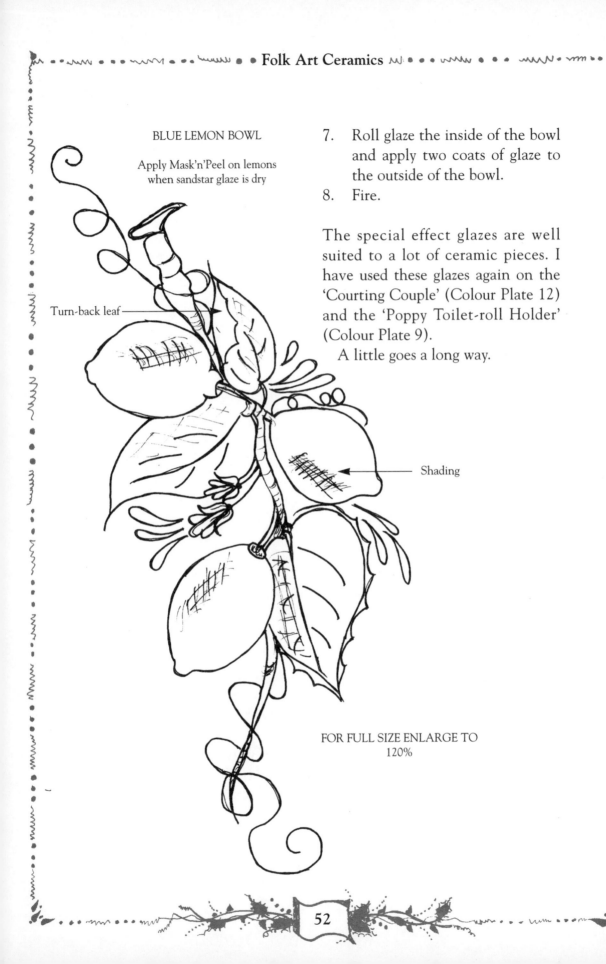

BLUE LEMON BOWL

Apply Mask'n'Peel on lemons
when sandstar glaze is dry

Turn-back leaf

Shading

FOR FULL SIZE ENLARGE TO
120%

7.   Roll glaze the inside of the bowl
     and apply two coats of glaze to
     the outside of the bowl.
8.   Fire.

The special effect glazes are well
suited to a lot of ceramic pieces. I
have used these glazes again on the
'Courting Couple' (Colour Plate 12)
and the 'Poppy Toilet-roll Holder'
(Colour Plate 9).
     A little goes a long way.

## Green Breakfast Set (Colour Plate 6)

CLEANING TIPS

Check the lid for a good fit. Clean the spout. The rim of the cup needs special care. Level the bases.

TECHNIQUES

LAFS. Underglazing. Wedge-brush background. Masking. Double-loaded strokes.

FIRINGS

Two.

GLAZING

Food-safe. Roll glaze inside the cup, teapot and bowl.

COLOURS

Underglaze: Gum-leaf green. One strokes: Dark and medium green. White. Black. Medium and dark red. Medium blue. Yellow. Orange.

Bowl

Cup

Plate

Saucer

METHOD

1. Apply three coats of green underglaze, painting freehand in a wavy line on either the top or bottom of the pieces. You may need to mask off the area with tape. I applied solid colour to the base of the teapot and cup, to the top of the bowl and a little area inside the rim of the bowl. The saucer was solid colour in the middle and the plate was underglazed on the outside. The lid was solid colour on the knob and top.

   The remainder, that is all the unglazed area, including the bases, was patterned with the wedge brush.

2. Using the wedge brush, apply the pattern over the white area (see 'Wedge Brush', page 23), diluting the underglaze with water. Tap off the excess on a paper towel; it is meant to be a faint pattern on all the white.

3. Apply LAFS and stroke flowers along the border, add small dagger leaves. This design is meant to be a very light one, so pale colours are used — the feature is the underglaze colour.

4. Fire the pieces.

5. Wipe the pieces clean. Roll glaze the inside of the bowl, cup and teapot.

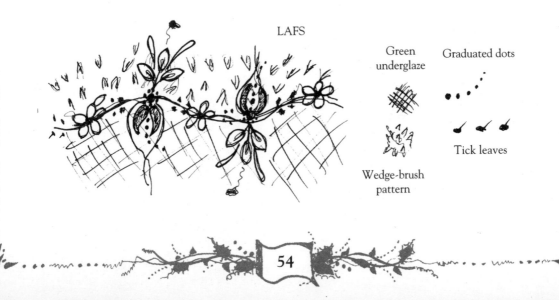

LAFS

Green underglaze

Graduated dots

Wedge-brush pattern

Tick leaves

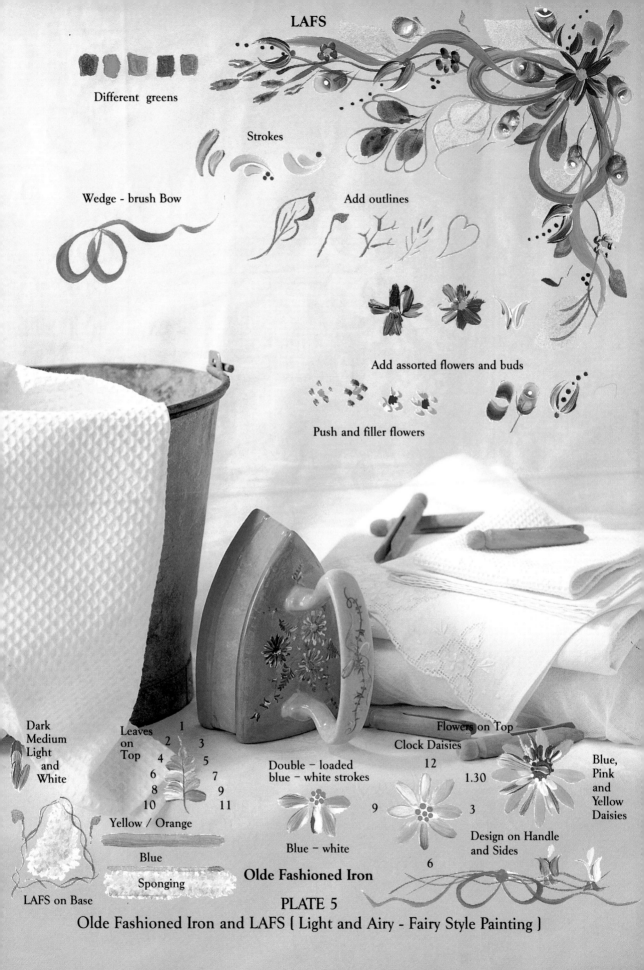

LAFS

Different greens

Strokes

Wedge - brush Bow

Add outlines

Add assorted flowers and buds

Push and filler flowers

Dark
Medium
Light
and
White

Leaves
on
Top

1
2      3
4      5
6      7
8      9
10     11

Yellow / Orange

Blue

Sponging

LAFS on Base

Double − loaded
blue − white strokes

Blue − white

**Olde Fashioned Iron**

Flowers on Top

Clock Daisies

12
1.30
9
3
6

Design on Handle
and Sides

Blue,
Pink
and
Yellow
Daisies

PLATE 5
Olde Fashioned Iron and LAFS ( Light and Airy - Fairy Style Painting )

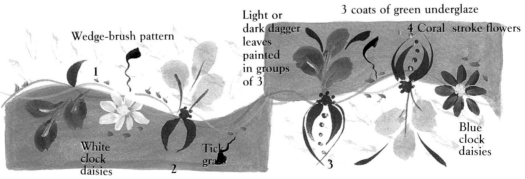

Wedge-brush pattern

Light or
dark dagger
leaves
painted
in groups
of 3

3 coats of green underglaze

4 Coral  stroke flowers

1

White
clock
daisies

2

Tick
grass

3

Blue
clock
daisies

1 – 4 shows steps for coral stroke flowers

**PLATE 6**
**Green Breakfast Set**

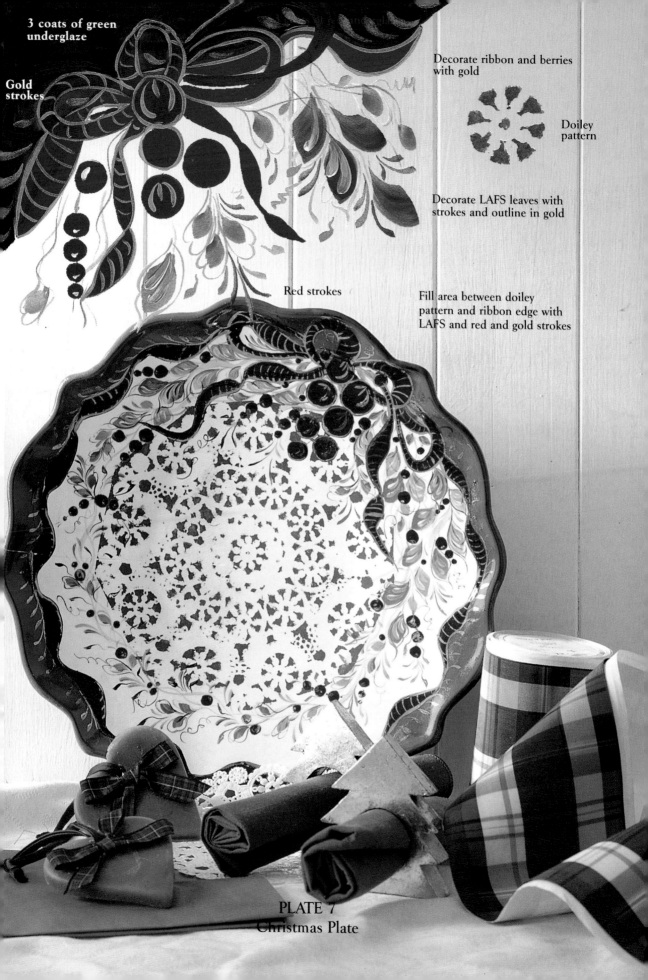

3 coats of green
underglaze

Gold
strokes

Decorate ribbon and berries
with gold

Doiley
pattern

Decorate LAFS leaves with
strokes and outline in gold

Red strokes

Fill area between doiley
pattern and ribbon edge with
LAFS and red and gold strokes

PLATE 7
Christmas Plate

Outline all fruit
and vegetable in black

Paint LAFS trails and tendrils and
leaves where sponging finishes

Double-loaded
green – white
leaves

Shade

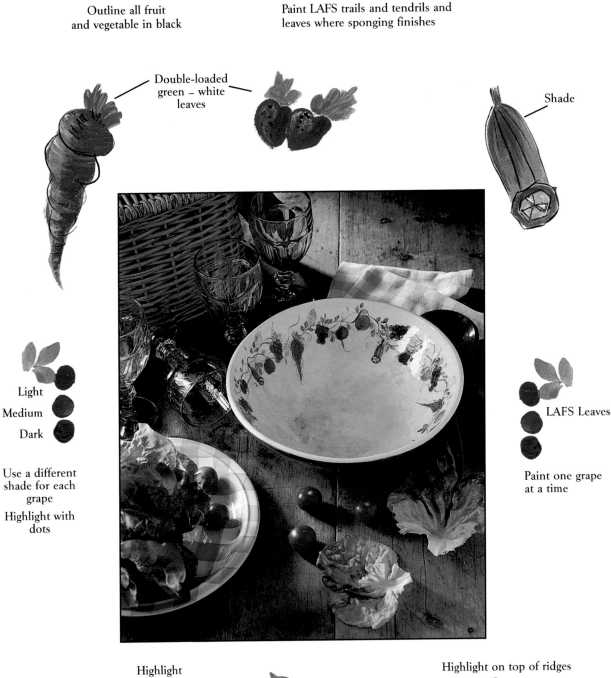

Light
Medium
Dark

LAFS Leaves

Paint one grape
at a time

Use a different
shade for each
grape
Highlight with
dots

Highlight

Highlight on top of ridges

See also 'Decorative Backgrounds',
Colour Plate 1, for sponging on
inside and slap-slip on outside of bowl

PLATE 8
LAFS Salad Bowl

6. Apply two coats of food-safe glaze to the rest of the set.
7. Fire.

The teapot, cup and saucer was a little set. Then I found the small cereal bowl and plate. Of course, you could get carried away here and paint a matching serviette ring, or salt and pepper shakers, an egg cup, and for two people to enjoy a cosy breakfast, another cup, saucer and bowl. And so on. I have also seen a small dish in the shape of a teapot for the teabags.

Have a nice breakfast.

## Christmas Plate (Colour Plate 7)

CLEANING TIPS
Level the base and clean the rim evenly.

TECHNIQUES
Underglazing with paper doiley. Tracing. Wedge-brush work. Stroke work. Dots. Squiggles. Red and gold liner work. Dagger-brush work.

FIRINGS
Three.

GLAZING
Food-safe. Red-safe. Read the labels.

COLOURS
Gold. Underglaze: Cherry red. Christmas green. One strokes: Red. Medium green. White.

METHOD
1. Apply three coats of green underglaze to the base, then apply three coats of the same underglaze to the front of the plate around the scalloped edge border. The wide band should be approximately 2.5 cm [1"] wide.

2. Place a paper doiley in the centre of the plate and gently apply two coats of green underglaze in the holes of the paper with a small Chinese brush. The doiley, whether paper or material, can be held in place with masking tape. Carefully remove the doiley to prevent smudging.

3. Trace the design for the ribbons, bows and berries if necessary. This is a simple design and can be freehanded.

4. Paint the ribbons, bows and berries with three even coats of red underglaze. The wedge brush is ideal for ribbons and bows. Practise on paper first. Thin the slip with water and apply pressure to produce a thicker line and no pressure for a finer line. For the loops, apply pressure on the down stroke, then release the pressure and come up, making a fine stroke.

5. Using a dagger brush, paint large medium green leaves and decorate with two double-loaded comma strokes. Paint small dagger leaves. Using the one-stroke slip, paint red comma strokes in the space between the doiley and the red ribbon. This space is filled with small red underglaze berries, stroke work, squiggles and dagger brush leaves and stems. The leaves are outlined with red or green one strokes.

6. Fire the plate. Note that red colours may need a different firing temperature.

7. Wipe the plate clean. Apply two coats of food-safe and red-safe glaze.

8. Fire.

9. Clean with alcohol. Decorate with gold. The gold is applied in stripes on the ribbon, then outlined. The berries are highlighted with strokes and outlined. Squiggles are painted here and there. This, after all, is a Christmas plate and worthy of your decorating skills.

10. Fire.

It is important to read the labels carefully and use a food-safe red underglaze. Some reds contain lead, which, according to the labels, you should not use even if you are thinking of becoming pregnant.

Thankfully the lead is being taken out and some products are totally lead-free now. Red underglaze can behave oddly under some glazes.

It is one of the hardest colours to use and one never quite knows how it will turn out.

Doileys come in a variety of designs. You may need to cut and position several together before obtaining the design you want. Some people hunt for the lacy plastic tablecloths and place mats. They have interesting patterns and wipe clean. Hand crocheted doileys are useful too, as the underglazes will wash off them.

Happy doiley-design hunting and a Merry Christmas to you.

FOR FULL SIZE – ENLARGE TO 160%

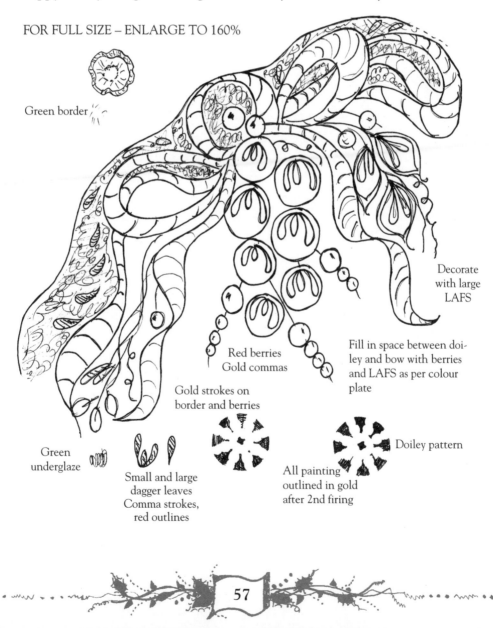

Green border

Decorate
with large
LAFS

Fill in space between doi-
ley and bow with berries
and LAFS as per colour
plate

Red berries
Gold commas

Gold strokes on
border and berries

Green
underglaze

Small and large
dagger leaves
Comma strokes,
red outlines

All painting
outlined in gold
after 2nd firing

Doiley pattern

## Tulip Vase (Colour Plate 2)

CLEANING

Check the turn-back part of the leaves. Do not sand-sponge over the leaves. The design is moulded onto the vase and has ridges down the leaves, so little sanding is necessary.

TECHNIQUES

Round-brush blending. Strokes. Underglazing.

FIRINGS

Two.

GLAZING

Clear glaze. Roll glaze inside.

COLOURS

Underglaze: Dark blue. One strokes: Light, dark and medium green. Dark and medium pink. Mauve. Yellow-orange. White.

METHOD

1.  Dry-brush blend all the leaves, applying shadow, light and high-lights (see 'Dry Brush Work', page 27).
2.  The tulips are painted with two coats of one stroke or underglaze colour. Long, white one-stroke comma strokes are painted on the tulips as a decoration (see colour plate).
3.  Using small brush, carefully apply three coats of dark blue underglaze in the gaps between the tulips and leaves. Use a wider brush for the remainder. Please mask off any area you feel needs to be given more care. By now, however, you are no doubt becoming very good at getting into difficult places with your different-sized brushes. Take it slowly. The underglaze could be applied first if you wish.

4. Because the tulips were above the level of the vase proper, I applied three coats of the dark blue underglaze about a third of the way down inside the vase. You may feel it looks better, too.
5. Fire the vase.
6. Wipe the vase clean. Roll glaze the inside. Apply two coats of clear glaze to the outside.
7. Fire.

This vase, which is quite dramatic in itself, could look stunning filled with large silk flowers and leaves. It could also look fabulous with a black underglaze.

## Small Jug and Basin (Colour Plate 3)

CLEANING TIPS
Level the bases, cradling the jug with towels or foam.

TECHNIQUES
Underglazes. Washes. LAFS. Black liner work.

FIRINGS
Two.

GLAZING
Pink-safe glaze. Roll glaze inside the jug.

COLOURS
Underglaze: Mauve. One strokes: Dark blue. Purple. Dark and medium green. Black. Dark pink. Yellow-orange.

LAFS FOR SMALL JUG AND BASIN

Daisies

Washes

Strokes — double-loaded
for violets and daisies

METHOD

1.  Dilute the mauve underglaze with water and lightly apply two coats around the rim of the basin and the jug handle. Add more water to the mauve colour under the rim of the jug to make the colour thinner. Compare the two results in the colour plate. The effect is a wash. Dilute the slip further and allow it to trickle down the jug to give a very very pale mauve wash. Quickly remove any excess with a damp sponge. Use your largest brush for washes.

2.  Paint the flowers freehand; these are a stylised type of violet, the larger leaves being like violet leaves or hearts. Refer to the colour plate for details on how to do these leaves. Use double-loaded dots and strokes to paint small filler flowers here and there. Place black squiggles and small leaves down the trails.
    Paint the design onto the inside of the bowl. You can also paint some white strokes around the rims as an added decoration. (See 'LAFS', Colour Plate 5, and Colour Plate 3.)

3.  Fire the pieces.

4.  Wipe the pieces clean and apply two coats of pink-safe glaze to the outside of the basin and jug, and roll glaze the inside of the jug and bowl.

5.  Fire.

In folk art, we use washes to give a soft misty look to our work. We may paint a flower or leaf and then apply many washes of more than one colour over the top to achieve this soft effect.

## LAFS Salad Bowl (Colour Plate 8)

CLEANING TIPS
Level the base.

TECHNIQUES
LAFS. Sponging. Slap-slip. Masking. Black liner work.

FIRINGS
Two.

GLAZING

Clear food-safe.

COLOURS

Underglaze or one strokes for slap-slip on the underside of bowl Light, medium and dark green. White. Yellow. Aqua. Underglaze or one strokes for sponging the inside of the bowl Light and medium yellow. White. Orange. Medium green. One strokes for sponging: Red. Orange. Purple. Brown. Black. Medium and dark green. All other one strokes used.

METHOD

1. Turn the bowl upside down and cushion on foam and paper. I have a turntable, which is most useful for these larger pieces. It saves handling the greenware.

2. In a plastic lid, set out the slap-slip colours. Wipe the bowl with glycerine mix. Working a small area at a time, slap the slip over the bowl; avoid creating ridges and aim for an interesting finish. Do not get underglazes on the rim. Dry well.

3. Mask off an irregular edge inside the bowl using small pieces of tape.

4. Sponge the inside of the bowl with the colours listed. Sponge a light touch of light green here and there. (See 'Decorative Backgrounds', Colour Plate 1.)

5. Refer 'LAFS' (Colour Plate 5). Paint trails and tendrils. Using a small dagger brush, paint clumps of leaves. Paint the stems on the leaves and the tendrils with dark green.

6. Draw the vegetable shapes onto the bowl with carbon pencil. Basecoat the shapes. Round-brush blend them. Outline all details with black using your fine liner brush. Paint in some squiggles. It is not hard to draw a carrot or round shape for an orange. Freehand wherever possible with the underglazes or one strokes.

LAFS

7.  Fire the bowl.
8.  Wipe the bowl clean.
9.  Apply two flowing coats of clear food-safe glaze.
10. Fire.

I loved painting this bowl. It is going to be very useful while still being decorative. It is a lot of painting, yet the personal satisfaction gained from this more than makes up for the time taken. Don't forget to sign and date your work before the final glaze is applied.

If this bowl is for a special event, a message could also be written on the bottom. After painting all the details on the fruit and vegetables you will now be very competent with fine liner work.

VEGETABLE SHAPES

## Poppy Toilet-roll Holder (Colour Plate 9)

This is a lovely piece to paint with slips and the special glazes, and allows us to use our folk painting skills on a large piece to be featured in the bathroom. Naturally, a toilet-brush holder would also look terrific done like this; perhaps half the design could be used. Ho hum. Painting never ends.

CLEANING

Level the bases.

TECHNIQUES

Traditional folk art design. Round-brush blending. Double-loading stroke work. Liner work. Tracing. Enlarge design. Dry-brush work.

FIRINGS

One. Two firings if roll glazing inside.

GLAZING

Roll glaze inside only if desired. Note: Areas of sandstar glazing and design are not clear-glazed.

COLOURS

Sandstar glaze: Yellow-orange. Yellow. Cream. Underglaze: Yellow. One strokes: Dark, medium and light green. White. Black. Light brown. Blue. Yellow.

METHOD

1.  Trace the design onto paper and then enlarge it to 120 per cent.
2.  Apply two coats of yellow underglaze to an area on the holder a little larger than the pattern.
3.  Trace the pattern. It is not necessary to trace every detail, just the outlines and a small line for strokes. Refer frequently to this design and to the colour plate.
4.  Paint the poppies and wheat first. These are painted with the special sandstar glazes. The wheat has one coat of each colour, brown one

stroke, then yellow-orange sandstar in smaller strokes, and finally small strokes using the cream sandstar glaze. Reverse the colours occasionally, applying the brown one stroke colour last.

5.  The poppies, daisies and tulip are all painted with three coats of sandstar glaze, then the darker sandstar glazes are blended gently to give shading or highlighting. Each flower is to be different.

6.  The strokes can be double-loaded at the time of painting. Embellish them with white liner work or strokes. Paint the green centres of the poppies with small double-loaded green—white strokes.

7.  The blue flowers have centres of the yellow-orange sandstar glaze.

8.  Fine black liner work details the wheat, daisies, poppy stamens and tulip petals.

9.  With a Chinese brush, paper towel and leftover colours on the palette, lightly dry-brush a little brown, green and black around the edge of the yellow underglaze to make a frame.

10.  Apply three coats of yellow sandstar glaze to the lid and the rest of the toilet-roll holder, apart from the base.

11.  Fire the holder.

12.  Wipe the holder clean.

At this stage, I could have roll glazed the inside of the holder and lid, but because it would hold paper and not water, and because of the nature of the special glaze, I decided not to do this; it was not necessary.

I did not apply the glaze to the base of this toilet-roll holder because the sandstar glaze has a rough texture. In ceramic painting there is a term called 'dry footing': no glaze is applied to the bottom or rim on the base of an article. Figurines, for instance, balance better when the base is rougher. Felt glued to the base of the article prevents scratching on your polished wood. Most ceramic pieces used for food should be glazed on the base, the exception being stoneware, which is non-porous. The 'Courting Couple' (page 72) was dry footed because there was not enough room in the kiln if it was stilted. The bases of these piece need to be lightly sanded and smoothed, to prevent them from scratching other surfaces.

POPPY TOILET–ROLL HOLDER                                    Centre

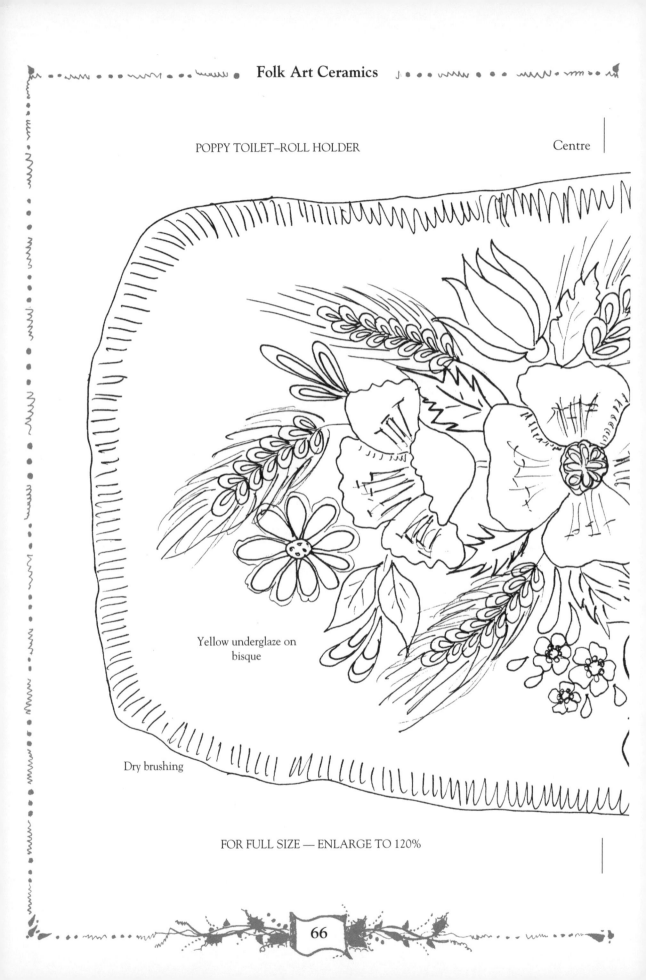

Yellow underglaze on
bisque

Dry brushing

FOR FULL SIZE — ENLARGE TO 120%

Centre

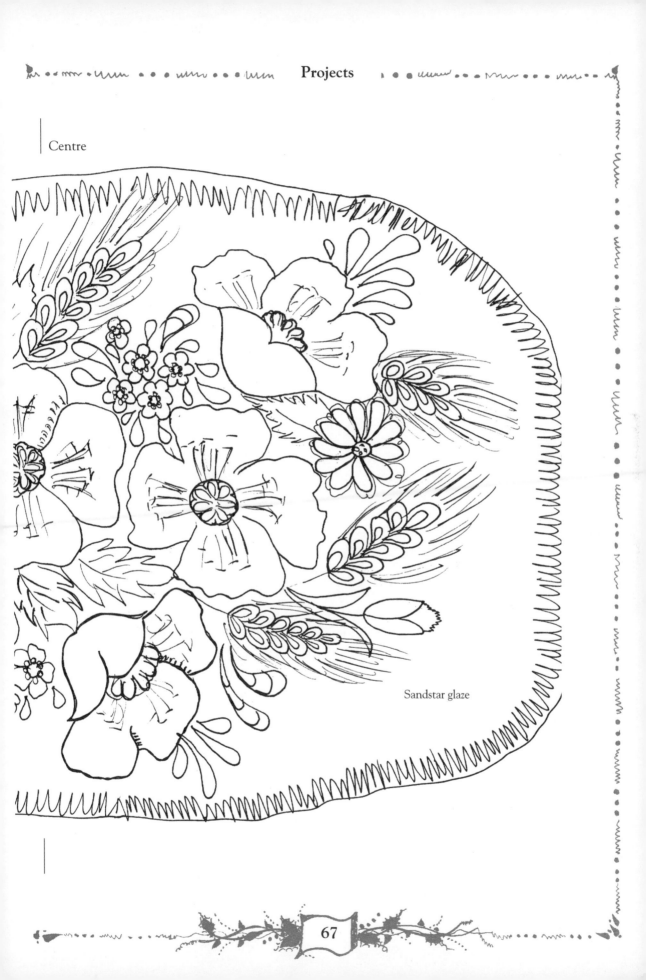

Sandstar glaze

## Pink Planter and Base (Colour Plate 3)

CLEANING TIPS

Level the bases.

TECHNIQUES

Sponging. Underglazing. LAFS. Flat-brush buds. Folk-art roses.

FIRINGS

Two.

GLAZING

Clear pink-safe.

COLOURS

Underglaze: Pink, for inside pot and base. One strokes: Dark, medium and pale pink. Dark and pale green. Blue. White.

METHOD

1.  Apply three coats of pink underglaze to the inside and rim of the pot and base.
2.  Put out the pinks, blue and glycerine mix on a plastic lid. Gently sponge a small area at a time on the alternate sides of the pot and base. Use the blue sparingly. Lightly overlap the joins and sponge under the rims with a very light sponge of pink, making a nice frame for your painted design on the alternate sides.
3.  Paint the design freehand. Paint some large green dagger leaves for the background. Using the small dagger brush, paint groups of darker green leaves here and there.
4.  Paint the folk-art roses next (see colour plate for details).

5.  Paint in some little filler flowers in pink and white, or dark pink and pink. Paint some little flat-brush buds here and there. Paint the stems and some little grassy leaves in dark pink.
6.  Mix a small amount of water into some pink slip to paint the bow.
7.  The base design is a bow with little fillers of stems. Paint the wisteria-like flowers by making patterns with an old brush, lightly dabbing in pink. If you paint each side of the pot and base differently it will look so much more distinctive.
8.  Fire the pot.
9.  Wipe the pot clean.
10. Apply two flowing coats of clear glaze.
11. Fire.

These lovely hand-painted pots are suitable for indoors or outdoors. I usually put a plant in a plastic container of a similar colour in the pot and position some coconut fibre over the gap.

When I visited an old temple in China, I saw in a corner, chrysanthemums growing individually in different-coloured pots. When I saw the greenware for the Pink Planter, it reminded me of this lovely sight. I am going to find pink chrysanthemums for mine.

Design for base

Light dabs of colour, using an old brush

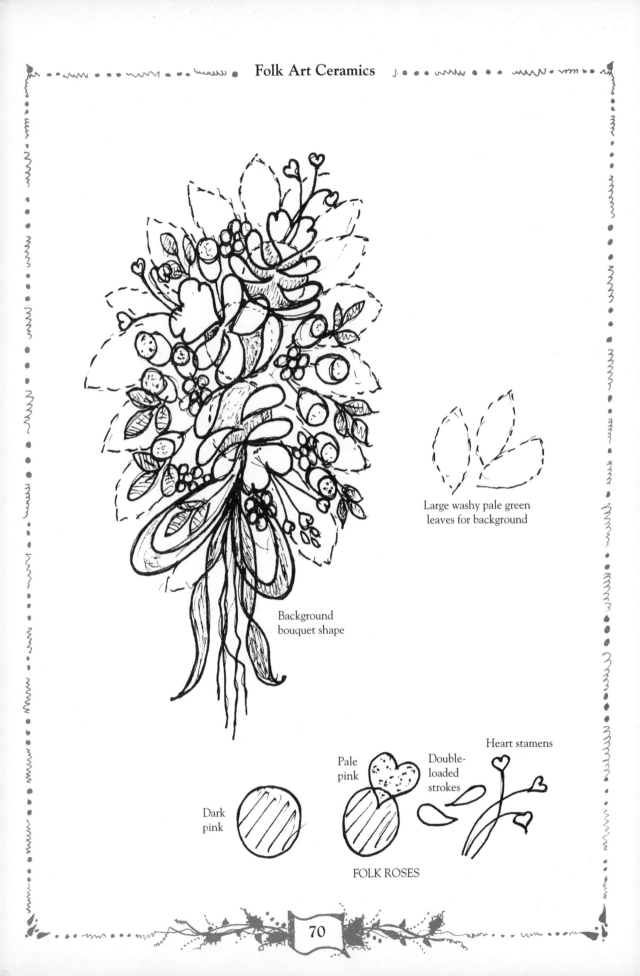

Large washy pale green
leaves for background

Background
bouquet shape

Heart stamens

Pale
pink

Double-
loaded
strokes

Dark
pink

FOLK ROSES

Light

Shade

Poppies

Daisy

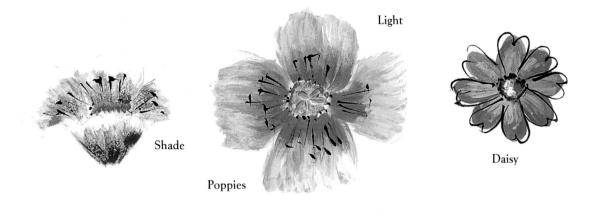

1   2   3

Wheat
Vary the
colours
Sandstar
glaze
Shade

Double-loaded
green – white
one strokes

Outline in green

1
2
3
4
5
6
7

Leaves

Shade

Poppy Bud

Sandstar
glaze used for dot
centres

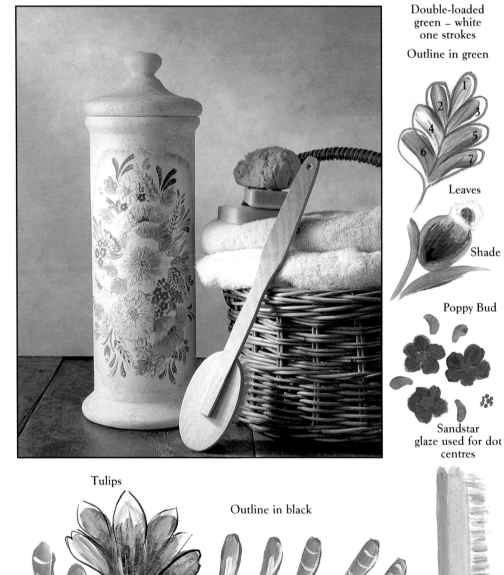

Black detailing

Tulips

Outline in black

Paint poppies, wheat and tulips with
sandstar glaze and shade

Decorate leaves with strokes

Dry - brush
along
underglaze
edge

PLATE 9
Poppy toilet - roll Holder

PLATE 10
Ashleigh's Tea Set

Stamens are
fine black lines

Use all the bright colours you have
Dry - brush with many colours

Paint
veins

**Saucer**

**Cup**

**Plate**

Decorate with small flowers and strokes

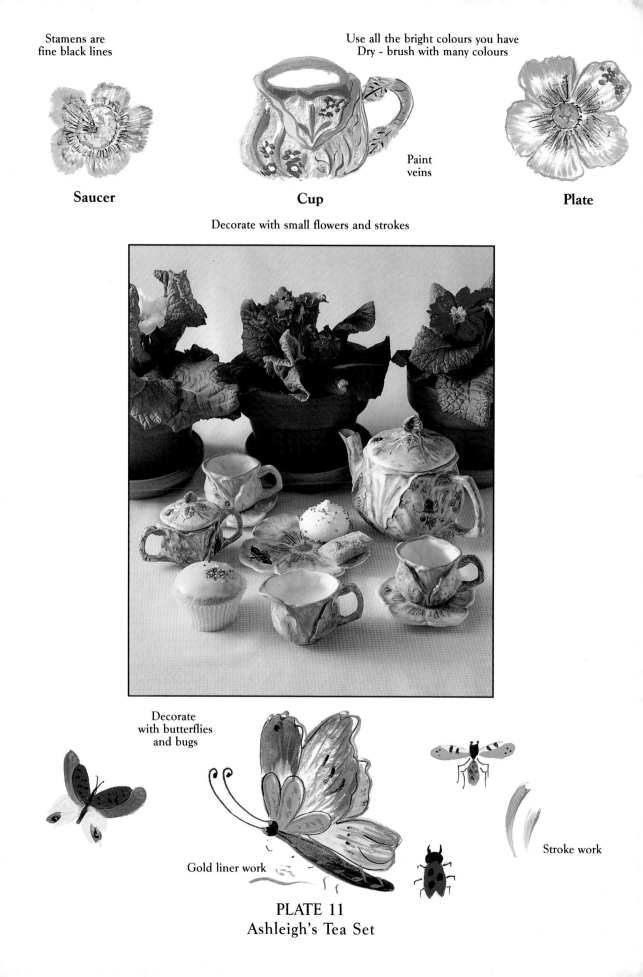

Decorate
with butterflies
and bugs

Gold liner work

Stroke work

PLATE 11
Ashleigh's Tea Set

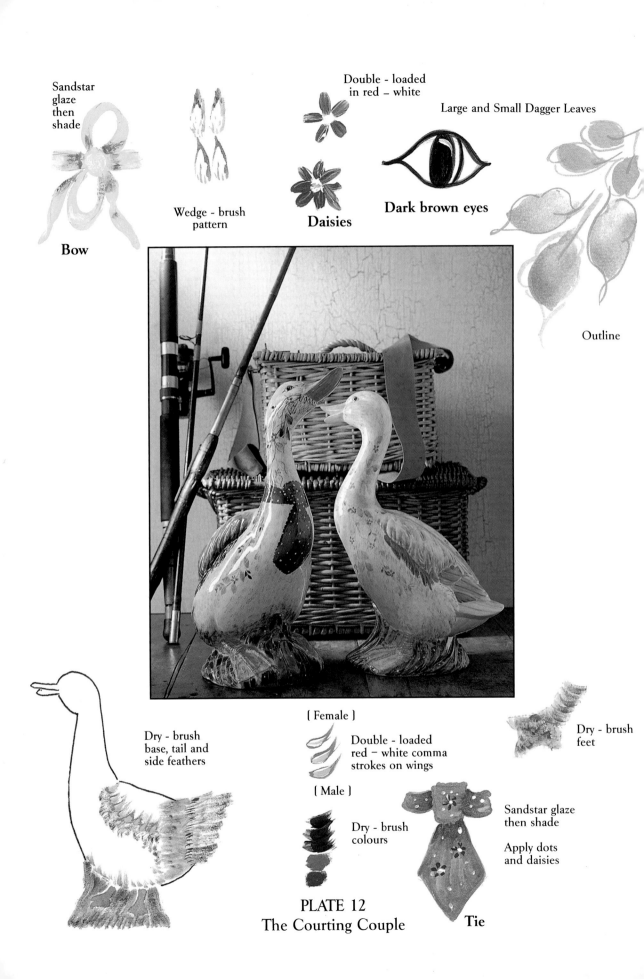

Sandstar
glaze
then
shade

**Bow**

Wedge - brush
pattern

Double - loaded
in red – white

**Daisies**

Dark brown eyes

Large and Small Dagger Leaves

Outline

Dry - brush
base, tail and
side feathers

[ Female ]

Double - loaded
red – white comma
strokes on wings

[ Male ]

Dry - brush
colours

Dry - brush
feet

Sandstar glaze
then shade

Apply dots
and daisies

PLATE 12
The Courting Couple

**Tie**

## Ashleigh's Tea Set (Colour Plates 10 and 11)

I wanted this tea set to be interesting, to please children and to become a family treasure and so have varied the designs and colours on each piece.

CLEANING TIPS

Level the bases. Check the spout of the teapot. Ensure that the lids fit.

TECHNIQUES

Dry-brush work. Stroke work. Tracing. Black and gold liner work. LAFS.

FIRINGS

Three.

GLAZING

Clear food-safe. Roll glaze inside.

COLOURS

All the colours you have on hand.

METHOD

1. Refer to the section on 'dry-brush work' (page 27) before starting. Handle or cradle the pieces carefully with towels or foam. Dry-brush several colours on top of each other, painting each of the pieces so that they are different in colour (see colour plate).
2. After each piece has been dry-brushed, paint on the flowers, bugs, snails, butterflies and LAFS, then paint all the liner work and details such as dots and stamens and strokes (see colour plate and page 73). Trace the bugs and butterflies, and basecoat the red ladybirds with either red underglaze or one stroke. Your choice of colours will depend on your dry-brush colours.
3. Using a fine liner brush and black one stroke, paint dates and details on the back. For example, 'Love from Nan' or 'Painted with love for your birthday', dated 23 August 1994.
4. Fire the pieces.

5.  Wipe the pieces clean.
6.  Roll glaze the inside of the pieces, then apply two coats of food-safe glaze.
7.  Fire.
8.  Wipe with alcohol.
9.  Detail with very fine gold on teapot lid, handles, veins in leaves, bugs, butterflies and flower centres.
10. Fire.

In this piece, the choice of colours is very much up to you. You will receive so much pleasure painting this little tea set. I would like your tea set to be interesting, to please children and to become a family treasure. I was delighted with the results I achieved; every piece was different. I settled on a box for it to live in. I lined the lid and box and did some folk painting on the outside. I put sugar lumps, tea bags, little milks and biscuits in, too. I made a tablecloth and tea towel so it became a portable afternoon tea party.

What a thrill we receive from making and painting something like this. I am so grateful and blessed to have found folk painting, and now, folk painting on ceramics.

## The Courting Couple: Female Goose and Male Goose (Colour Plate 12)

CLEANING
Level the base. Handle carefully, cradling the pieces with towels or foam.

TECHNIQUES
Dry-brush work. Wedge-brush work. LAFS.

FIRINGS
Two.

GLAZING
Clear glaze. Sandstar glaze: yellow for the bow and green for the tie.

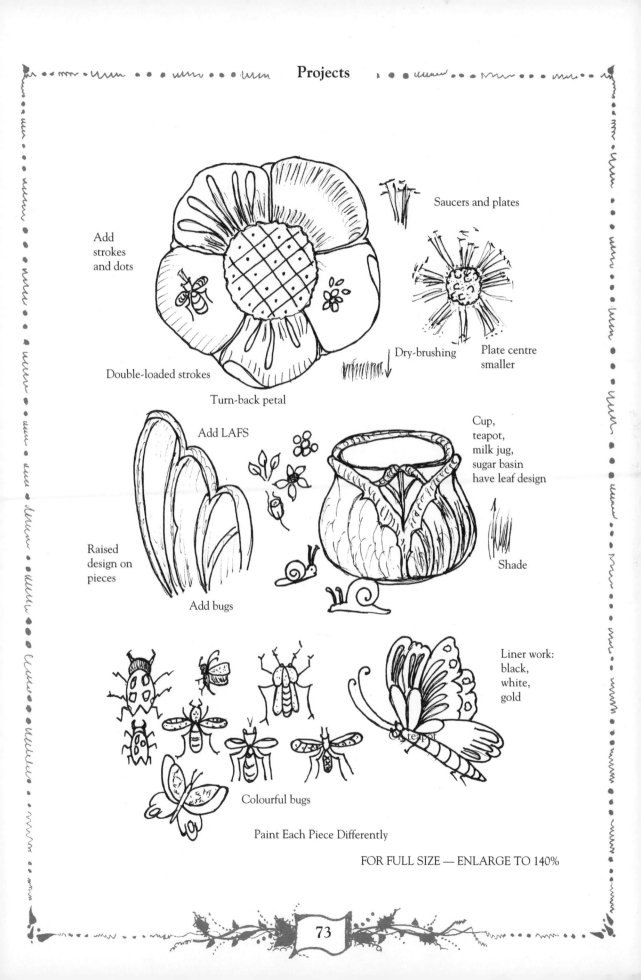

Add strokes and dots

Saucers and plates

Double-loaded strokes

Dry-brushing

Plate centre smaller

Turn-back petal

Add LAFS

Cup, teapot, milk jug, sugar basin have leaf design

Raised design on pieces

Shade

Add bugs

Liner work: black, white, gold

teapot

Colourful bugs

Paint Each Piece Differently

FOR FULL SIZE — ENLARGE TO 140%

COLOURS

Underglaze: Yellow. One strokes: White. Light and medium brown. Orange. Yellow. Dark and light peach. Coral. Dark, medium and light green. White. Blue-green. The darker values were used on the male.

METHOD

*The Female*

1. This lovely goose has been waiting and wading through weeds, so the base is dry-brushed with greens. Using the small and large dagger brushes, paint contrasting green leaves on top. Paint small stroke coral daisies with a white dot in the centre here and there.

Bases are dry-brushed and painted with
dark leaves and double-loaded daisies

2. Underglaze the feet with two coats of yellow. When dry, the feet should then be dry-brushed with orange, then light brown.
3. Do the beak in the same way.
4. The pattern is painted over the body, except for the wings and tail, using the wedge brush. Make a mix of the dark peach and water, tap off any excess slip

on a paper towel and apply in one direction, putting the pattern closer together on the head. The result is a soft feather effect.

Wedge-brush pattern

5. Dry-brush the wings and tail feathers in peaches, browns and blue-green. Apply large comma strokes of peach on the back to resemble more feathers.

6. Paint LAFS. Paint small trails of large and small dagger leaves on the back, near the neck and front of the goose.

Paint bow with dots

Shade

7. Apply two coats of yellow sandstar glaze to the bow around the neck. Apply some white dots here and there if you wish. Where the ribbon crosses, shade with a little yellow-orange sandstar glaze. Glaze is going to be painted on top of this after the first firing. It softens the sandstar glaze, but the textured look still remains.

8. Refer to illustration and the colour plate for details on painting the eye.

9. Fire the piece.
10. Wipe the piece clean.
11. Apply two coats of clear glaze, except on the base which is to remain dry-footed.
12. Fire.

Brown eyes
White strokes

Shade

Paint tie with dots
and daisies

*The Male Goose*

The male goose has also waded through the weeds, so the base is the same. I have used much stronger colours for him, going one or two

shades deeper. However, the two geese can be painted in exactly the same colouring if you want to have a matching pair.

Follow the instructions for the female goose, but note the following differences. The male goose does not have any decorative strokes on his back, and has his best floral tie on. The tie is painted with three coats of green sandstar glaze, then daisies and dots here and there. This completes this courting goose's outfit. A trail of stems, dagger leaves and flowers are in his beak, as he is out to impress the lady by offering flowers.

Daisies

Paint LAFS trails and leaves on base of male goose

I felt that these geese took on a character of their own. There would be many other ways to paint this pair. I have seen them in plain glazes, which are quite effective, but now that you have learnt to paint with slips and have gained more painting skills, your birds will be very much admired.

I really loved painting these geese. Painting on a large surface makes us think a lot about colour, and we become more creative and adventurous. There are many large shapes such as animals, pots, vases and platters all waiting for you to decorate.

# List of Suppliers

*(Please note these suppliers are those in my local area only)*

### ALDAX INDUSTRIES PTY LTD
64 Violet Street Revesby NSW 2212. Telephone: (02) 772 1066
All ceramic and craft supplies

### ALDERSON'S CRAFT SUPPLIES
Railway Parade Kogarah NSW 2217. Telephone: (02) 587 2699
All ceramic and craft supplies

### THE GLAZED LOOK
152 Garnet Road Kirrawee NSW 2232. Telephone: (02) 521 1952
Toothbrush Holder, Olde Fashioned Iron, Lemon and Orange Daisy Bowl
LAFS Salad Bowl, Small Jug and Basin, Brown Dinner Plate, Christmas Plate,
Blue Slap-slip Vase

### HARVEY'S HOBBY CERAMICS
128 Bonds Road Riverwood NSW 2210 Telephone: (02) 533 5581
Blue Lemon Bowl, Pink Planter

### JACKIE'S CERAMICS
17 Station Street Engadine NSW 2233. Telephone: (02) 520 2132
Dark Blue Vase

### SOMETHING CERAMIC
47 Wills Road Woolaware NSW 2230. Telephone: (02) 527 3094
Geese (Courting Couple), Poppy Toilet-roll Holder, Ashleigh's Tea Set,
Tulip Vase, Sponged and Spattered Plate, Green Tea Set Bowl

### SUZANNE'S HOBBY CERAMICS
Kumulla Road Miranda NSW 2228. Telephone: (02) 524 8693
Jewellery Box, Green Breakfast Set